FOR THE LOVE
OF PEANUTS

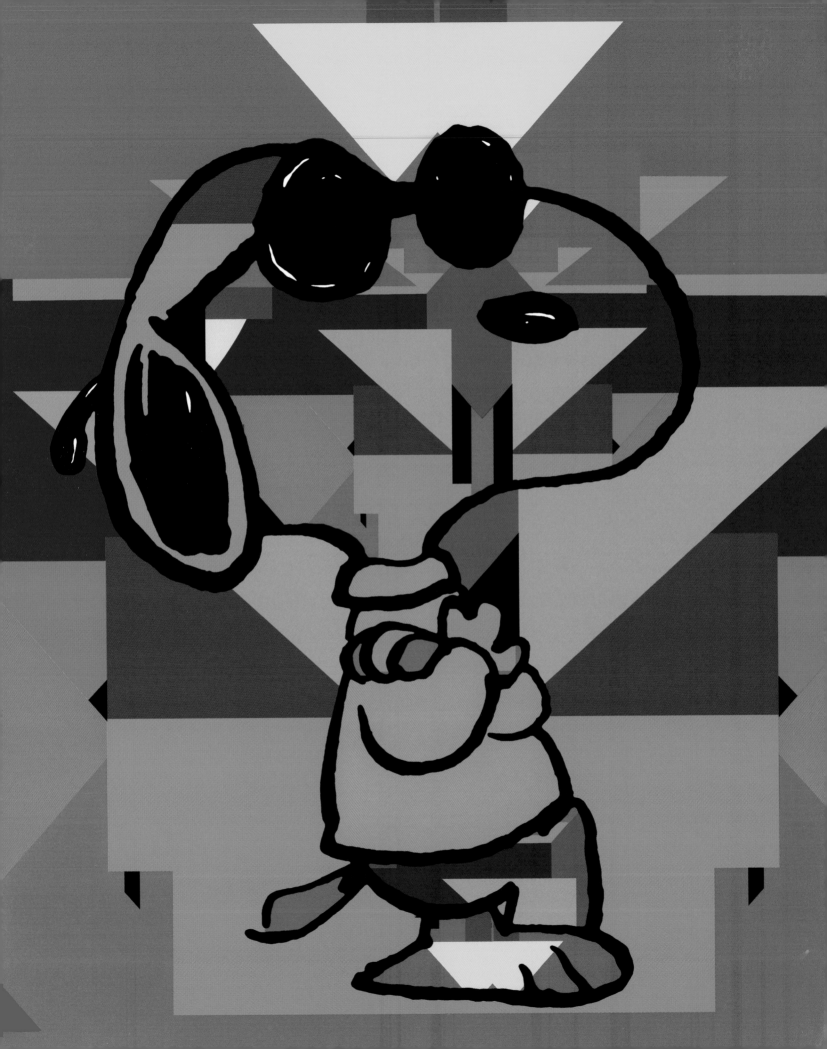

FOR THE LOVE OF PEANUTS

CONTEMPORARY ARTISTS REIMAGINE
THE ICONIC CHARACTERS OF
CHARLES M. SCHULZ

INTRODUCTION BY LINDSEY A. SCHULZ

PEANUTS™
GLOBAL ARTIST COLLECTIVE

Written by Elizabeth Anne Hartman

Foreword by Yvonne Force Villareal

BLACK DOG
& LEVENTHAL
PUBLISHERS
NEW YORK

Black Dog & Leventhal Publishers
Hachette Book Group
1290 Avenue of the Americas
New York, NY 10104

www.hachettebookgroup.com
www.blackdogandleventhal.com

Image credits on p. 136 constitute an extension of the copyright page.

First Edition: April 2019

Black Dog & Leventhal Publishers is an imprint of Running Press, a division of Hachette Book Group.
The Black Dog & Leventhal Publishers name and logo are trademarks of Hachette Book Group, Inc.

The publisher is not responsible for websites (or their content) that are not owned by the publisher.

The Hachette Speakers Bureau provides a wide range of authors for speaking events.
To find out more, go to www.HachetteSpeakersBureau.com or call (866) 376-6591.

Print book interior design by Frances J. Soo Ping Chow

Library of Congress Control Number: 2018958663

ISBNs: 978-0-7624-6679-5 (hardcover); 978-0-7624-6767-9 (ebook)

Printed in China

1010

10 9 8 7 6 5 4 3 2 1

CONTENTS

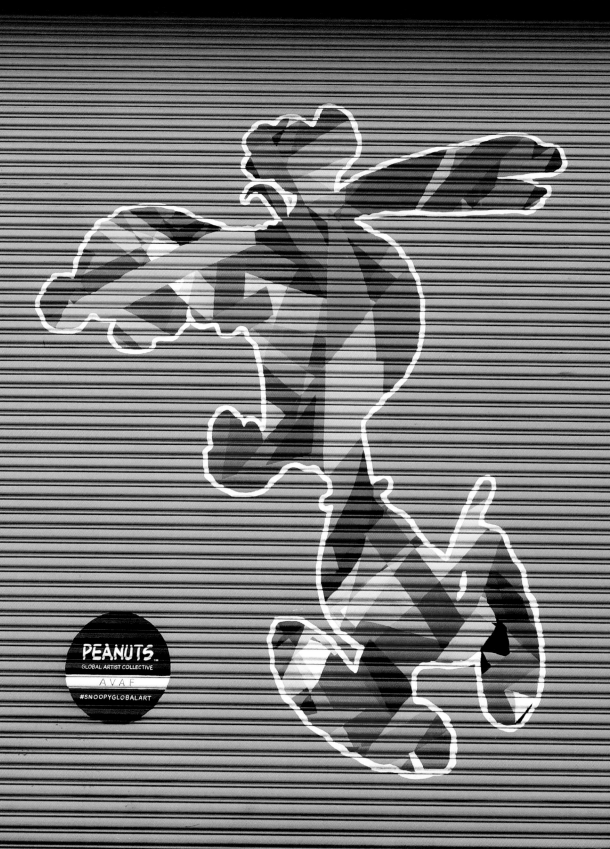

FOREWORD

When I was 8 years old, I wrote a fan letter to Charles Schulz. While I could not pinpoint it then, I related to the Peanuts gang and their complex emotions. Peanuts seemed to speak to a larger truth, one that I was seeking in my everyday contemplation of the world around me. In response to my letter, Mr. Schulz sent a large print of all the Peanuts characters, signed by the artist himself.

Little did I know that later in my life would I be working with the Peanuts team and an amazing group of contemporary artists in order to celebrate and extend Charles Schulz's legacy. In November 2013 we had our first meeting to discuss the possibility of having artists collaborate with the Peanuts brand.

To me, this seemed like a natural fit: Many artists, like Christo, Kaws, Tom Everhart, and Rob Pruitt, have incorporated Snoopy, Charlie Brown, or Woodstock into their work already. Peanuts has embraced these coincidental collaborations. In the case of Christo, of whom Schulz was an admirer, Schulz used a Christo-inspired wrapped Snoopy doghouse in one of his comic strips. Twenty-five years later Christo returned the compliment by creating *Wrapped Snoopy House*, a life-sized doghouse on permanent display in the Charles M. Schulz Museum in Santa Rosa, California.

After our initial meeting with Peanuts, we put forth the names of more than 100 contemporary artists who we felt would be a natural fit for a collaboration with Schulz's creations. We thought of the core imagery and values of the Peanuts body of work, and chose artists who mirrored or expanded on these themes. Many of these artists were already using an animated quality and exploring a pop aesthetic. Conceptually, we selected artists who were dealing with the human condition in a humorous manner.

We finally landed on seven incredible contemporary artists, all of whom share a deep connection to Peanuts and a long-standing commitment to public art: André Saraiva (Mr. A), Nina Chanel Abney, AVAF, FriendsWithYou, Tomokazu Matsuyama, Rob Pruitt, and Kenny Scharf. With these seven artists, the Peanuts Global Artist Collective was launched to create public art projects and commercial collaborations.

◀ 1.

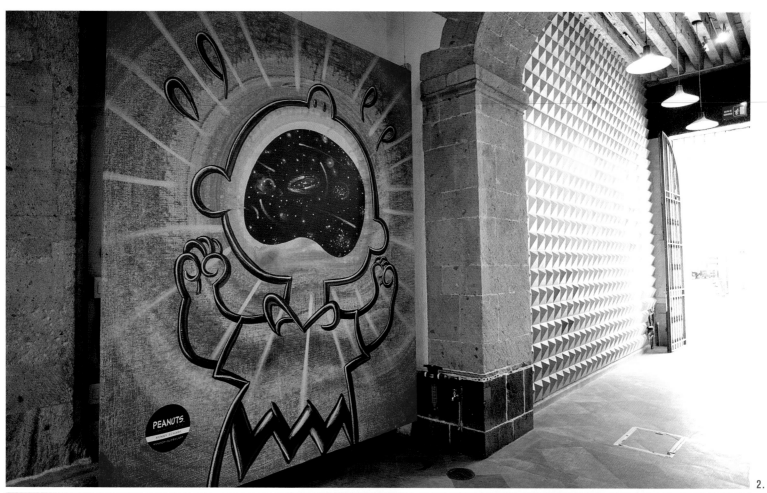

2.

3.

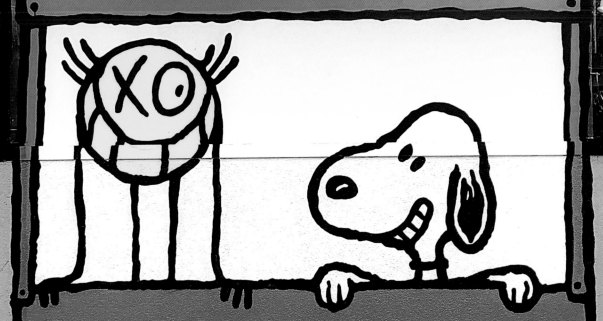

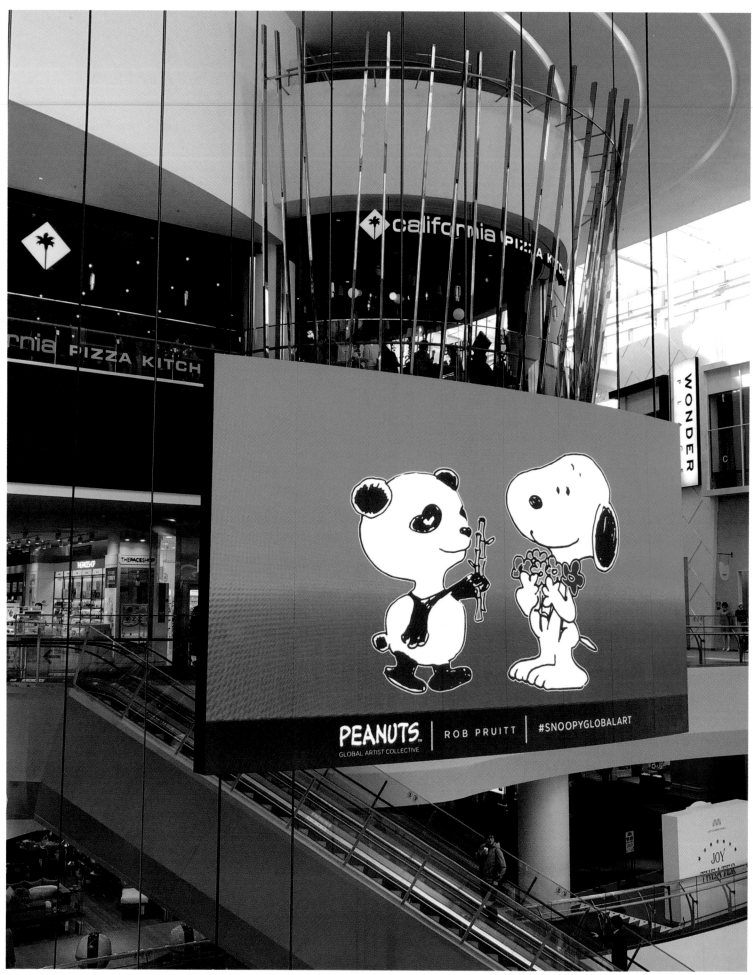

6.

7.

André Saraiva (Mr. A) used graffiti as the first way to make his mark on the world. Now an established hotelier, restaurateur, and nightlife pioneer, Saraiva has never put away his spray can. His playful character Mr. A, as he is best known, stylistically fits right in with the Peanuts characters.

Nina Chanel Abney is known for combining representation and abstraction in a saturated color palette. Her paintings capture the frenetic pace of contemporary culture in subjects as diverse as race, celebrity, religion, politics, sex, and art history. She was a natural pick for a collaboration with Peanuts.

assume vivid astro focus (AVAF) was founded by Brazilian-born artist Eli Sudbrack in 2001, and uses a vast array of media, including painting, drawing, installations, video, sculpture, neons, wallpaper, and decals. His colorful, high-energy work mirrors Schulz's humor.

FriendsWithYou is the fine art collaborative of Samuel Albert Borkson and Arturo Sandoval III, working collectively since 2002 with the sole purpose of spreading the positive message of Magic, Luck, and Friendship—an obvious continuation of Peanuts themes.

Tomokazu Matsuyama's work responds to his own bicultural experience of growing up between Japan and America by bringing together aspects of both Eastern and Western aesthetic systems. His work with Peanuts offers a new perspective on iconic images.

Rob Pruitt is an American post-conceptual artist who works primarily in painting, installation, and sculpture. He is perhaps best known for his ongoing series of pandas as well as gradient paintings. He also is known for his use of Peanuts characters in his work already, which made him an easy choice with whom to collaborate on this project.

Kenny Scharf is an American painter and installation artist who is associated with the Lowbrow movement and who was part of the East Village art scene during the 1980s. He is best known for his visually dynamic work inspired by comic books and pop culture.

After Peanuts made their selections, the first thing the artists were asked to do was to visit the Schulz Museum, and to view his active studio. While in Santa Rosa, they met Jean Schulz, Charles's widow, and gained access to all of Schulz's original works, archives, and fonts. This experience helped the artists develop personal connections not just to the Peanuts brand, history, and artwork, but also to the humanity of Mr. Schulz himself.

We then asked each artist to come up with three ideas for public art projects, which ranged from murals to roller-skating rinks to monumental interactive inflatables. What speaks to me the loudest about this collaboration is that Peanuts launched it with a public mural project. Art has always been the true foundation of this project, and I believe it is exemplified in every aspect of the process.

The very essence of our mission was to honor Charles Schulz as, first and foremost, an artist, and to expand the legacy of Peanuts through the visionaries of our time.

YVONNE FORCE VILLAREAL, 2019

FIGURE 1: AVAF, New York City; FIGURE 2: Kenny Scharf, Mexico City; FIGURE 3: FriendsWithYou, Mexico City; FIGURE 4: Mr A, New York City; FIGURE 5: Rob Pruitt, Seoul, South Korea; FIGURE 6: Tomokazu Matsuyama Tokyo, Japan; FIGURE 7: Nina Chanel Abney, Paris, France; FIGURE 8: Tomokazu Matsuyama, Berlin, Germany.

INTRODUCTION

As a child I would visit my grandfather at work; I would walk through the office filled with toys, books, and blankets. The colorfulness, which vibrated as I entered the building, diluted into deep, rich tones of navy and wood as I moved into the back room. I bounded across the carpet and stood by his side, watching his hand glide across the paper, leaving a trail of ink from beneath his grip. As he both rigidly and gracefully tossed his hand around the paper, a familiar image began to appear: Linus's profile. It blew my mind that my grandpa could so accurately draw this character.

Once, at the ice arena he built across from the studio, I asked if I could buy a hot chocolate, and my mom told me to put it on our family's tab. I stood at the counter, barely able to see over it, and with my voice wavering with complete uncertainty, I told them my mom was Judy. They looked at me blankly, and I ran back to my mom in utter confusion and embarrassment. I eventually learned that hot chocolates went on the "Schulz" tab. However, it wasn't until my grandfather passed away that the magnitude of his life and accomplishments hit me. At the time, I had no idea why so many strangers had shown up to his memorial. I had no idea so many people were reading the same drawings he made that I, too, was reading. The impact of his career came to me in waves, and still, I am reaching new levels of comprehension. My thesis as an undergraduate appropriated text from the strip, and in graduate school I began to read more about what he was saying with the strips, rather than what he had the characters say. Every studio visit I had with visiting artists, professors, or peers seemed to begin with each person's personal experience with Peanuts. And though I am so proud to be related to such a passionate, decent, and exceptional artist, he will always first be my grandfather, who liked to draw.

Art inherently possesses the ability to communicate and removes the hostility that can be found in the limitations of language. Revolutions gain momentum through artists and their capacity to critique the current landscape, baked into the camouflage or boldness of their medium. From the beginning, Peanuts tackled controversial issues under the guise of childhood innocence. From civil rights, feminism, and religion to psychiatry, philosophy, and depression, Schulz, known to his family and friends as "Sparky," used the characters to negotiate these issues into the mainstream discourse. The universally relatable and

minimalist quality of the strip allowed room for the complexity of the content. This wasn't an accident, but a strategic decision that evolved during the early years of the strip.

Abstract expressionist Jay Meuser said, "It is far better to capture the glorious spirit of the sea than to paint all of its tiny ripples." Schulz began to distill the strip, sacrificing his technical expertise in perspective for an intimate bond between his characters and the readers. He said, "As the strip grew, it took on a slight degree of sophistication, although I have never claimed to be the least sophisticated myself. But it also took on a quality that I think is even more important, and that is one which I can only describe as abstraction . . . Snoopy's doghouse could function only if it were drawn from a direct side view. Snoopy himself had become a character so unlike a dog, he could no longer inhabit a real doghouse."

Sparky often talked about Picasso and his great sense of design, though his own use of abstraction created a new language within cartooning. Picasso said, "A face has two eyes, a nose, and a mouth. You can put them where you want." As long as Sparky could capture the essence of a dog, a bird, a kid, the visual gaps that lie between those marks opened up the panel for the viewer to insert themselves. The features of each character shifted with the direction of their gaze, and the sight of both eyes placed on the side of one's head was no longer jarring.

Sparky made endless references to artists, writers, and musicians in the strip: Vincent van Gogh, Thomas Eakins, Rod McKuen, F. Scott Fitzgerald, John Gay, Leo Tolstoy, Ludwig van Beethoven, Andrew Wyeth; but in a lot of ways I believe his subtlety was overlooked. In a drawing titled "Things I've Had to Learn Over and Over," we see Sally standing in front of a messy closet under a pull-string lightbulb. This hanging bulb is a recurring image in mid-century abstract expressionist Philip Guston's cartoonish paintings of the 1960s, taken from his childhood experience in which he would hide in the closet, reading and drawing under the single bulb.

With Sparky's title in mind, Guston wrote, "I knew that I would need to test painting all over again in order to appease my desires for the clear and sharper enigma of solid forms in an imagined space, a world of tangible things, images, subjects, stories, like the way art always was."

Sparky and Guston shared in common a fascination with the comic strip *Krazy Kat*. Sparky said in an interview, "I just wanted to draw a comic strip that was regarded as highly as *Krazy Kat*. *Krazy Kat* is regarded as probably the greatest strip that was ever drawn. And I just want to contribute something that would be that good."

For generations Peanuts has narrated our life, voiced our insecurities, and revealed what true happiness is. The strip had a unique ability to speak to a universal and ageless audience, something that makes it still relevant for today's young readers. The Peanuts Global Artist Collective has been given the exciting responsibility to interpret his characters through the lens of their individual practices. There has always been a reciprocal relationship between Peanuts and fine art, and to expand that conversation into public spaces brings the conversation back to the foundation of the original medium: accessibility. Charles M. Schulz said, "Not many cartoons live into the next generation, and that probably is the best definition of art, isn't it? Does it speak to succeeding generations? Real art, real music, real literature speaks to succeeding generations. And not many comic strips do that." It is undeniable by his own definition to argue that Peanuts is real art, and Sparky, my grandfather, was a true artist.

LINDSEY A. SCHULZ, 2019

FOR THE LOVE OF PEANUTS

"I'M PRETTY OBSESSED WITH ALL THINGS PEANUTS."

— Nina Chanel Abney

NINA CHANEL ABNEY

NINA CHANEL ABNEY roared onto the art scene in 2007 with a single painting—*Class of 2007*. It was her final thesis project at Parsons School of Design, where she received an MFA. The painting depicts Abney, who is black, as a white, gun-toting prison guard with a flowing blond mane and her classmates, all of whom were white, as black inmates. When Chelsea gallery owners Marc Wehby and Susan Kravets saw the painting, they signed her immediately. They sent a photograph of the painting to Mera and Don Rubell, Miami-based art collectors and founders of the Rubell Family Collection, who bought it, sight unseen, to appear in the 2008 *30 Americans* show, which showcased works by 30 important, contemporary African-American artists of the last three decades. The exhibit, which has toured museums and galleries in America since 2008, focuses on issues of racial, sexual, and historical identity in contemporary culture while exploring the powerful influence of artistic legacy and community across generations.

Abney has continued to make headlines with her work. In 2015, *Vanity Fair* featured a profile entitled "How Nina Chanel Abney Is Championing the Black Lives Matter Movement with a Paintbrush." And a December 2017 *Hyperallergic* review of two of her shows declared that the artist "paints on the edge of violence." But to talk about Abney painting in any one particular way, or to express any one particular sentiment, is a misrepresentation. She is emphatic on this point: "While I touch on certain issues, I try to keep everyone guessing. I never want to be in one land."

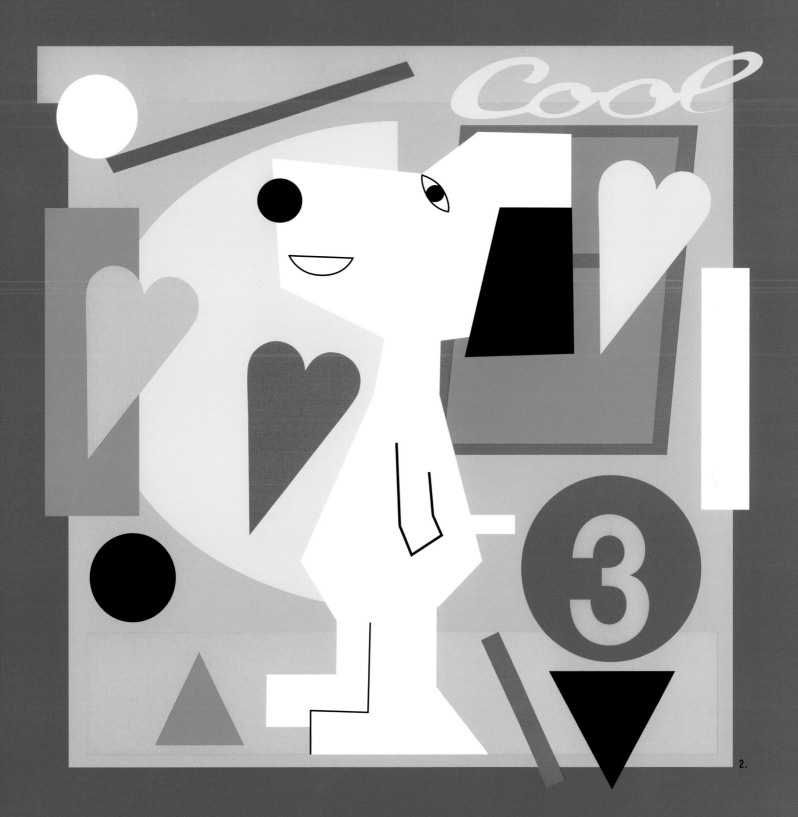

FIGURE 2: Snoopy, according to Abney, can be cool without his sunglasses.

"I want to talk about a million other topics that touch everybody."

By way of comparison, while Schulz's strips often expressed social and political commentary, it was always subtle—nibbling, not biting, not to mention that Schulz's first African-American character didn't appear until 1968, and only after the prompting of a Los Angeles teacher, Harriet Glickman. Eleven days after the assassination of Dr. Martin Luther King Jr., she wrote to Schulz: "Dear Mr. Schulz, since the death of Martin Luther King, I've been asking myself what I can do to help change those conditions in our society which led to the assassination and which contribute to the vast sea of misunderstanding, hate, fear and violence." He responded, expressing concern that if he created such a character, black parents might think he was condescending to their families. A dialogue ensued, and Franklin was born.

And yet, social commentary had long been a part of the Schulz oeuvre, the most self-evident of which is Woodstock, named after the iconic 1969 music festival that represented the flower-power generation. Lucy "leaned in" with her assertiveness, and can be consid-

ered the Sheryl Sandberg of the Peanuts gang. And Peppermint Patty, uber tomboy, might be described as a "gender-bender" in today's parlance.

Likewise, while Abney doesn't deny that her work can be confrontational and provocative when it comes to race, she is clear about not wanting to be boxed into a corner, as she puts it. "I want to talk about a million other topics that touch everybody," she said in an interview with a curator at the Institute of Contemporary Art, Los Angeles, Jamillah James, in the exhibition catalog that accompanied her 2007 show, *Royal Flush*, at the Nasher Museum of Art at Duke University.

Abney draws from a wide variety of sources for inspiration: the 24-hour news cycle, video games, hip-hop culture, celebrity websites, tabloid magazines, anything in the newspaper, music, what's on her Instagram and Facebook feeds, and, last but not least, animated cartoons and comics—in particular Peanuts. Growing up in Harvey, Illinois, a suburb of Chicago, Abney happily admits to being "pretty obsessed with all things Peanuts": the comic books, the movies, and even her

Peanuts bedsheets that she crawled into every night. As a child, Abney played at pretending to be the characters from the Berenstain Bears, Archie comics, and Disney, but it was Peanuts—and Snoopy above all—who captured her imagination and stole her heart. Her favorite Peanuts movie was *Race for Your Life, Charlie Brown*, and Abney recalls making her own raft to re-create the scene with the boat race. She also would cut out characters from the comics and turn them into toys, an activity that has metamorphosed into her artistic process. "I see this as part of my work today, how I kind of collage images together."

Abney's interest in cartoons didn't end in childhood. A bold colorist in her own work, she admires the way cartoonists often "used colors to draw the viewer in and

then be kind of forced to grapple with the subject matter. Visually the work is appealing to a lot of people. It's approachable. Then when they get in front of it they realize that it's more than just a pretty picture." This same assessment—easy to swallow, hard to digest—has often been applied to Abney's work as well. Nevertheless, like Schulz, Abney says, "If possible, I'm trying to reach everyone from all walks of life."

To that end, over the ten-plus years since *Class of 2017* put her on the map, Abney's style has evolved, becoming somewhat flatter. "I became more interested in simplifying my figures and creating a language where anyone could approach the work, regardless of their artistic knowledge." Sentiments that could have been expressed by Schulz.

THE WORK

It's no surprise that when approached to be a part of the PGAC, Abney jumped at the opportunity to "filter those characters through my vision," she said. She focused on Snoopy and Woodstock because those were the two figures that she was most drawn to as a child, but Snoopy reigned above all. "I wanted to filter Snoopy into my world, and in Nina world, most figures are squared off," she explained. "My figures start out more figurative, but then go off and become more abstract, so that's what I wanted to do for Snoopy and Woodstock."

The process of reimagining Snoopy and putting her own stamp on it was slow. "I felt a lot of pressure, like I'm gonna kind of redo Snoopy. I mean, it's so known. How do you make it different?" So she began in the same way she does with most of her work, whether it's painting or collage—with shapes and colors. "I don't sketch anything out," she says. "Everything is completely intuitive. I basically start with the subject matter and a very solid color and then start building up shapes. At the beginning of the process, I'm just laying down patterns and shapes." For Snoopy, she cut paper into shapes that represented Snoopy's body, mouth, ears, et cetera, and moved the parts around until she came upon images that she liked.

To make Snoopy her own, Abney asked herself, if Snoopy were a part of her world interacting with her figures, what would they look like and what world would they live in? In keeping with the graphic style of so many of her figures, she began by creating a squared-off version of Snoopy and Woodstock. "In a similar way," she explains, "I layered imagery in back of them and on top

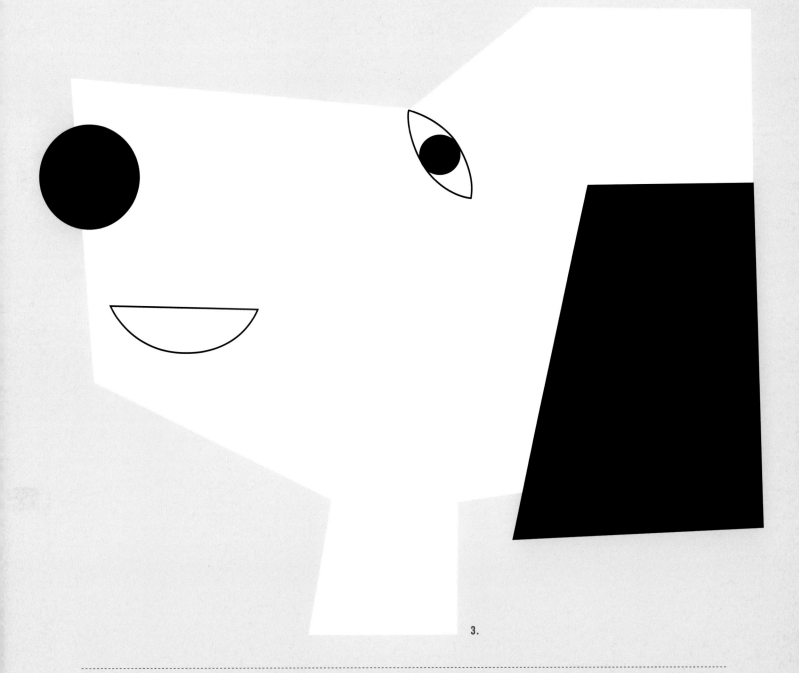

3.

FIGURE 3: Abney begins simply with color and geometric shapes. Snoopy's mouth is a half-circle, the nose is a perfect circle, and the ear is rendered as a trapezoid. The eye is all Abney's—the style that she uses in many of her works—not the oval or line that was Schulz's.

"WHAT ELEMENTS WILL GET THE ESSENCE OF SNOOPY ACROSS?"

of them, and that's usually how I work. I will start from a background in colors and use a layering process." And, as always in her work, whether it's commercial, commissioned, or fine art, she still has to start off with creating actual physical paper cutouts. From there she scans them into a computer and manipulates them as needed.

With Snoopy, "Once I got the face, I thought I was done," she said, "and then thought, oh my God, I have to make a full body." Schulz is known for the simplicity of his drawings, but Abney found re-creating the figure a bit daunting. "What does his arm look like? What elements will get the essence of Snoopy across?" The challenge,

- -

FIGURE 4: Here Snoopy's signature sunglasses are rendered as easily replicated geometric shapes. "I wanted to create something that could be manipulated in endless ways. So if I can just create the basic figure, then the possibilities of what I can do with that are limitless."

FIGURE 5: "Once I created a basic Snoopy, I used a 'paper doll approach,'" is how Abney describes the process of adding elements to the composition. Here she has tucked Snoopy into a baseball cap.

she added, was to maintain the recognizable Snoopy that everyone knows and not manipulate it too much.

To make it her own, beyond squaring off Snoopy, she added familiar elements from her works that are replete with an array of symbols including hearts, X's, numbers, words, and other signature marks. The meaning of Abney's marks varies from work to work. An X could represent the familiar kiss, or it could mean "no," or symbolize censorship. Other repeating motifs, such as a blade of grass, are meant to be a universal symbol everyone understands in his or her own context. The grass icon could represent, at once, the manicured lawns of suburbia, the grasslands of Africa, or the Scottish Highlands (Figure 1). But sometimes a hot dog is just a hot dog, and in her interpretation of Peanuts, Abney insists that her symbols are primarily design elements.

What Schulz accomplished with line, Abney did with shapes. Snoopy's mouth is a half-moon, his nose is a perfect circle, and his ear is a trapezoid. "What Schulz did with line is amazing, so I thought, 'How can I re-create that feeling but with my own tools?'" Snoopy's eyes, drawn by Schulz as either an oval or a line, become Abney's

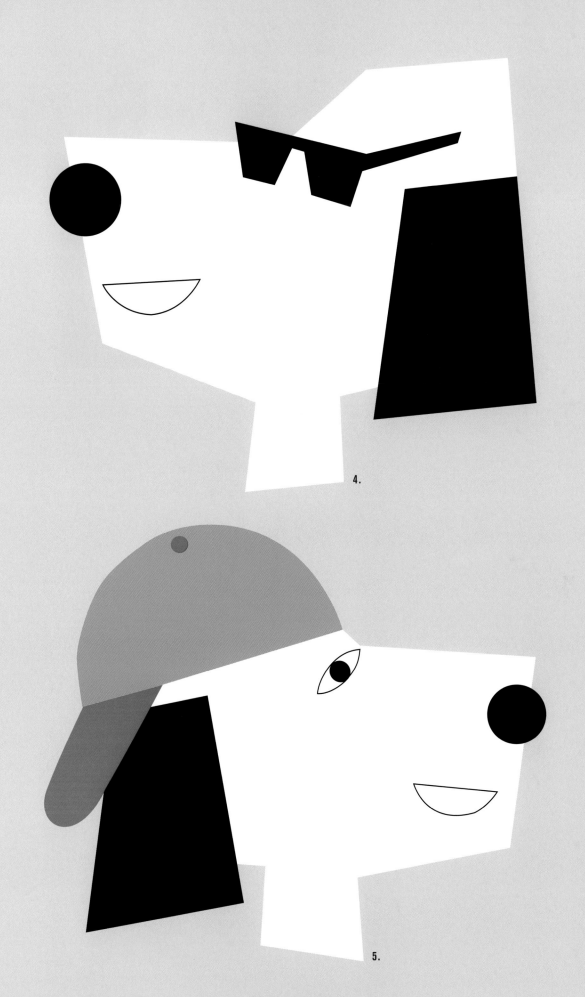

4.

5.

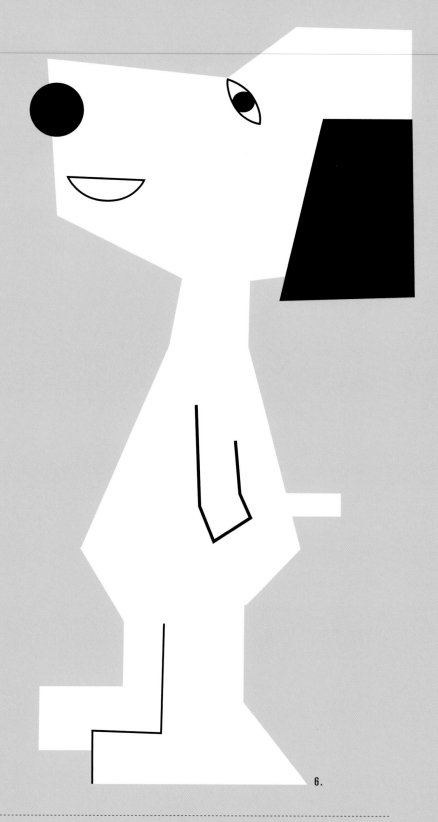

6.

FIGURE 6: "Once I got the face, I thought I was done," she said, "and then thought, oh my God, I have to make a full body."

FIGURE 7: Here, Abney is bringing in more collage elements with her signature hearts.

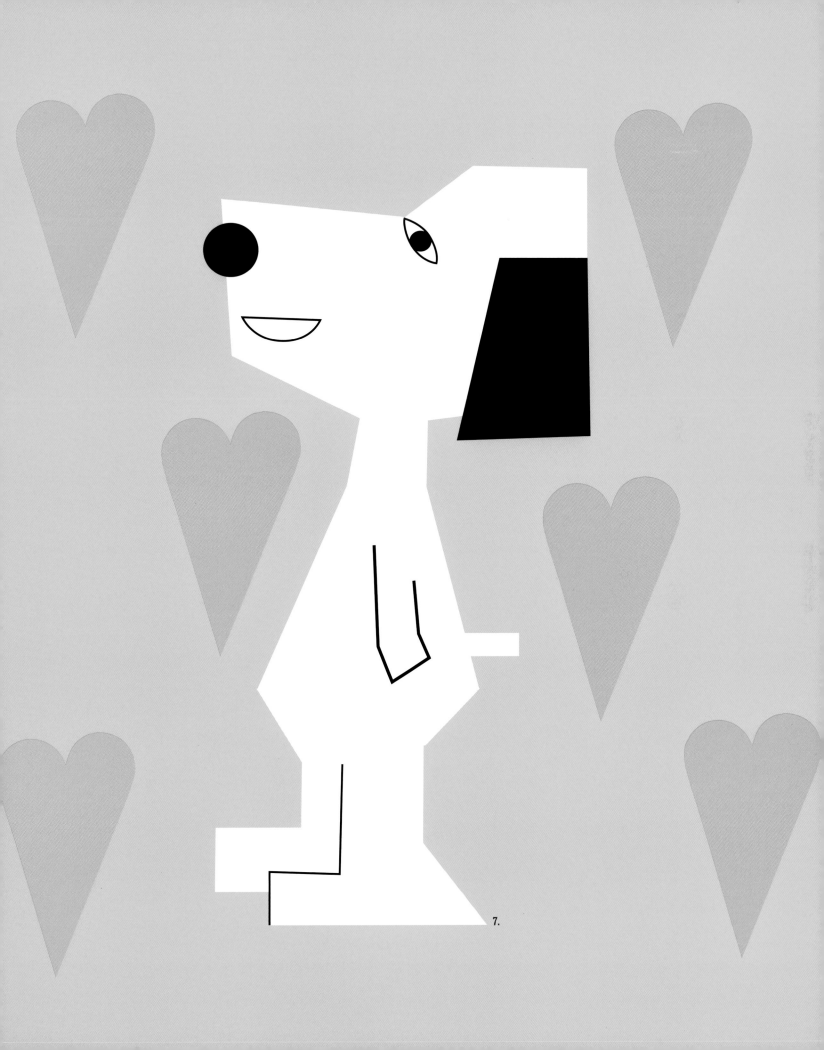

7.

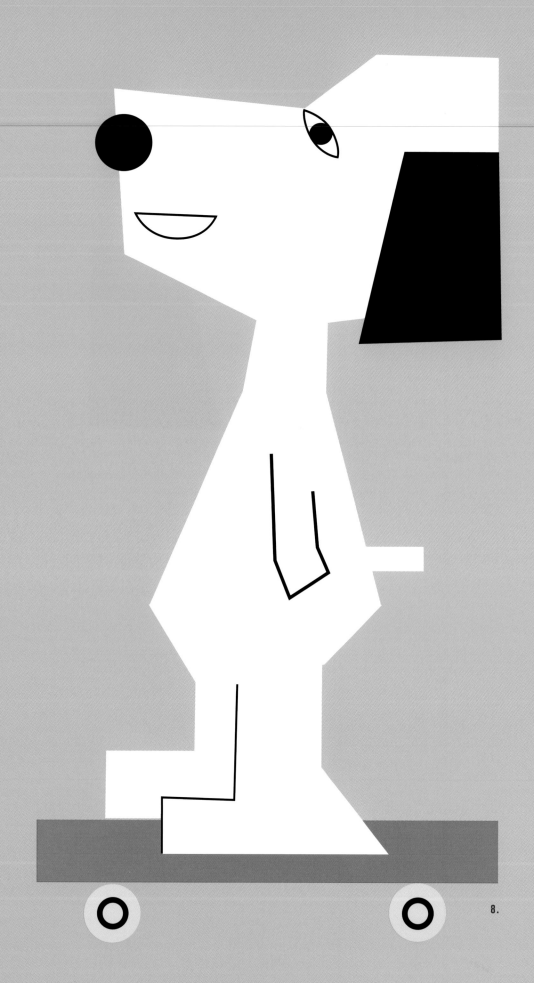

8.

signature eye (Figure 3). Woodstock's iconic hair is enhanced in Abney's work to become fatter and more geometric (Figure 9). In Nina's world, the circular sunglasses that define Snoopy's "Joe Cool" persona become square, as do Woodstock's.

Clear common ground between Schulz and Abney is found in the combination of images and words. Schulz created a narrative through his characters' dialogues and thought bubbles, while Abney, through a sparse sprinkling of words in her work, creates an unspoken dialogue between the artist, the work, and the viewer. And like Schulz, Abney strives for enduring work. "It's very inspiring to see—someone able to create such a legacy and something that's timeless, so that's what I really try to do in my work. Even though I respond to things in the moment, but to kind of portray them in a way that can still be reinterpreted years later."

--

FIGURE 8: "Once I was able to get the figures down, I was able to have them in action." Here is Snoopy on a skateboard.

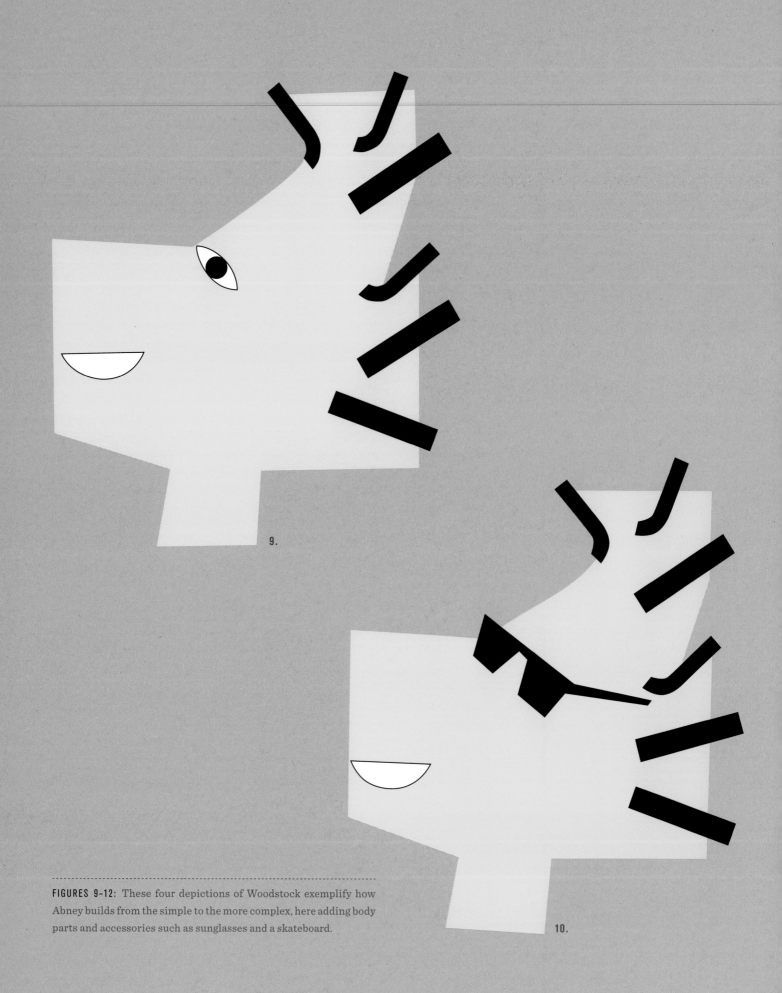

9.

10.

FIGURES 9–12: These four depictions of Woodstock exemplify how
Abney builds from the simple to the more complex, here adding body
parts and accessories such as sunglasses and a skateboard.

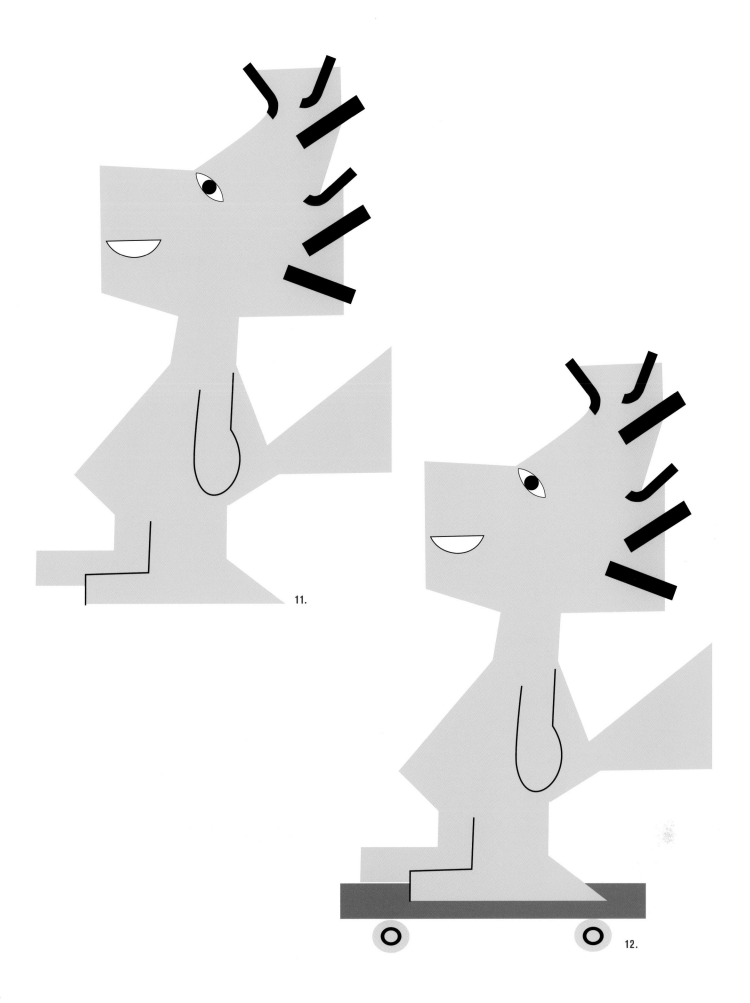

11.

12.

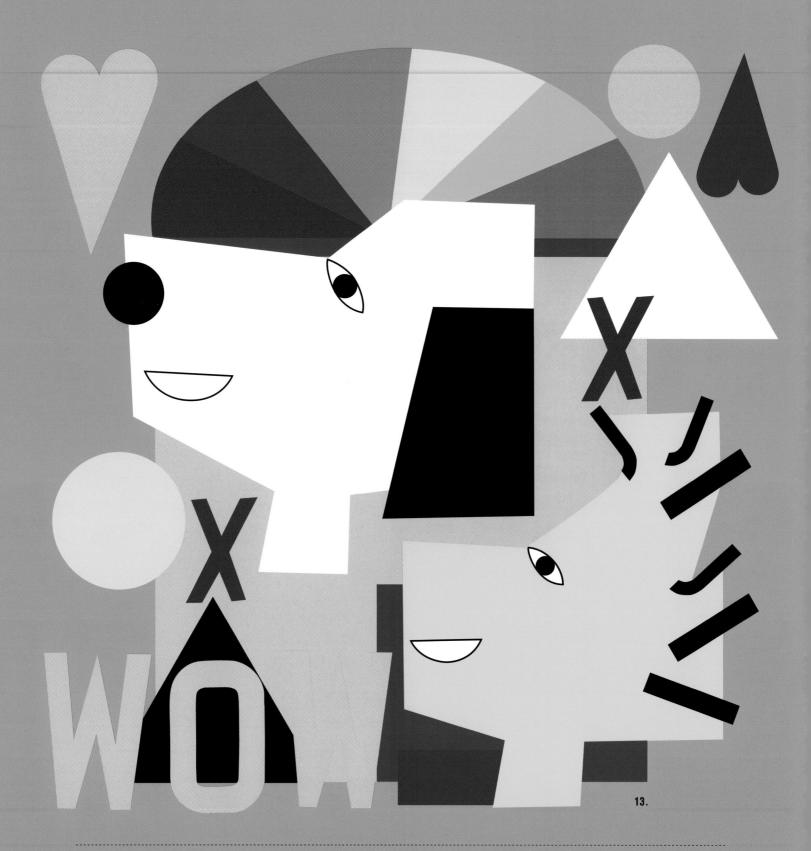

FIGURES 13-14: As a child, Abney would cut out characters from various comics and turn them into toys, an activity that has metamorphosed into her artistic process. "I see this as part of my work today, how I kind of collage images together." Here, she has used her signature elements—blades of grass, X's, and hearts—and collaged them with her interpretations of Snoopy and Woodstock.

"Joe Cool against a colorful abstract background with many of Abney's signature marks."

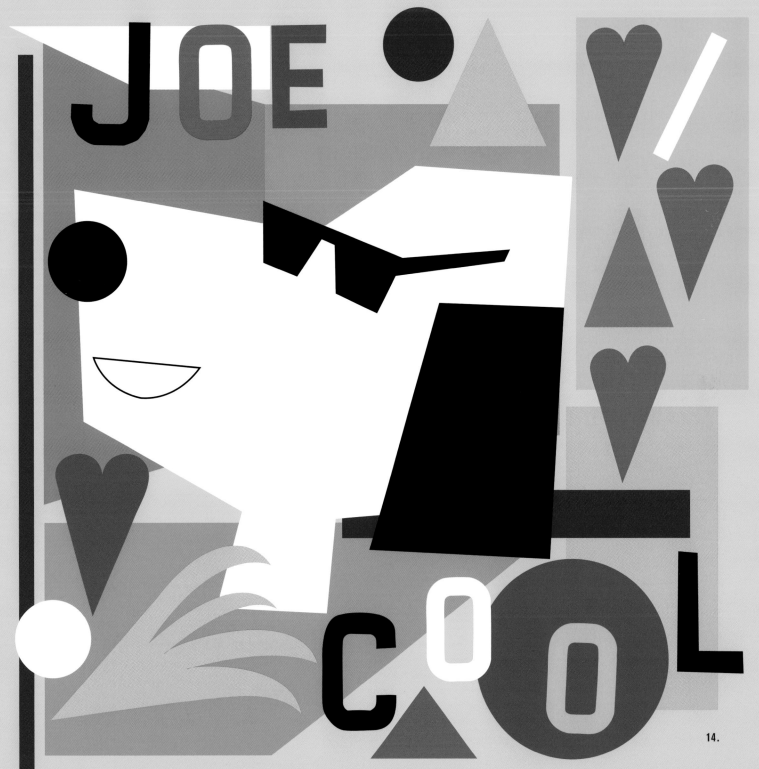

14.

"I WANT TO MAKE THE PEANUTS GANG EXPLODE AND DANCE IN A DIFFERENT ENVIRONMENT, OUTSIDE THE COMIC STRIP."

—

AVAF

The bold, Brazilian contemporary artist **ELI SUDBRACK** might seem an odd choice to reinterpret the art of a gentle genius such as Schulz. Sudbrack is the creative force behind AVAF, which (sometimes) stands for assume vivid astro focus and is (sometimes) a collective. In his work, commercial and private, solo or collective, from paintings and wallpaper design to murals and installations, Sudbrack has not shied away from addressing difficult sociopolitical issues, often portraying transgender and hyper-sexualized figures in his works. Sudbrack is not subtle. With his art, he advocates "the freedom to share, spread, absorb, assume, contaminate, inseminate, and devour." In contrast, Schulz simply loved what he did every day and was grateful that millions around the world did, too.

Stylistically, too, the two artists appear worlds apart. Schulz used "only what's necessary," as Jeff Kinney, author of the Diary of a Wimpy Kid series, put it, to render his world of Peanuts. Sudbrack's signature style is audacious and brazen, rendered with a bold confidence in a riot of color and pattern. Schulz eschewed backgrounds; Sudbrack layers a multitude of them.

But then again, Woodstock brought a dose of 1960s flower power, Lucy took on a tinge of feminism in the 1970s, and the athletically talented "tomboy" Peppermint Patty may have taken a first swipe at gender stereotypes. Schulz's subtler brand of social commentary was embraced worldwide, long before globalism was a mandate or a given. It was, by its nature, inadvertently inclusive. And it is this inclusivity and accessibility that is at the core of everything that AVAF does.

Inclusivity is the reason Sudbrack prefers a pseudonymous acronym to his own name. He is emphatic that his work is not about him. "I had this utopian idea that other people could actually *assume* astro focus; I wanted people to feel that they were part of it. My work does not function without the viewer. The viewer is always the focal point, the centerpiece of everything that I've created."

AVAF can mean almost anything; it is open to change and reinterpretation as needed. For a 2014

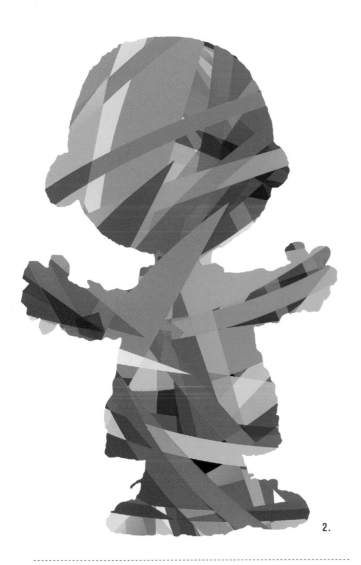

2.

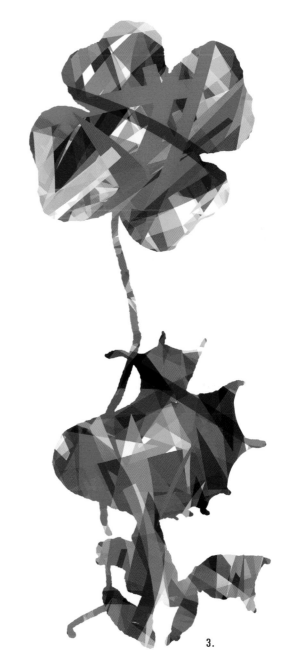

3.

FIGURE 2: At first, Sudbrack experimented with turning the characters into total abstractions defined by their profiles, but that didn't quite work. Instead, he settled on filling in a defined silhouette with his signature patterns. "It's his bowling ball head and the position of his body that lets you know this could only be Charlie Brown," says Sudbrack.

FIGURE 3: The depiction of Woodstock holding a flower is one of the most memorable motifs for Sudbrack because, he says, "For me, that was my personal and emotional context for Peanuts while growing up. I was immersed in the legacy of the Woodstock festival and the cultural trope of flower power. I just love this image and the way it self-references Woodstock's name." Woodstock first appeared in the comic strip in 1967, but his name remained undisclosed until 1970.

"I want the outcome to be positive, I want the total sensorial experience of my work to be uplifting."

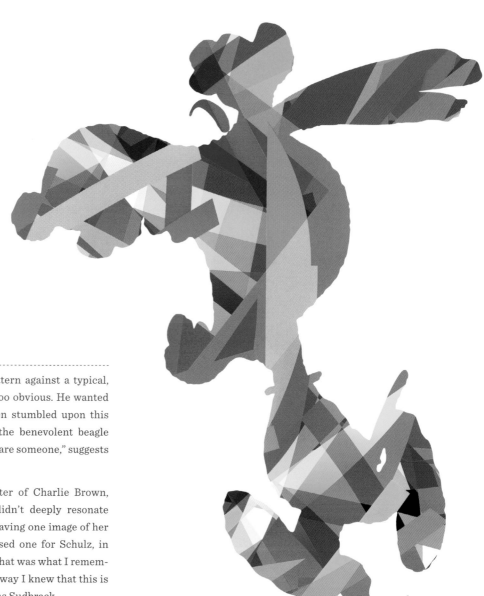

FIGURE 4: When Sudbrack set the pattern against a typical, still shape of Snoopy, the result was too obvious. He wanted something more challenging, and then stumbled upon this unusual image of Snoopy in which the benevolent beagle appears angry. "I think he's trying to scare someone," suggests Sudbrack, "maybe Woodstock?"

FIGURE 5: Sally, the blonde little sister of Charlie Brown, always spewing big malapropisms, didn't deeply resonate with Sudbrack, but he does admit to having one image of her emblazoned in his memory—an oft-used one for Schulz, in which Sally is clutching pom-poms. "That was what I remember as being characteristic, and right away I knew that this is how I wanted to represent her," explains Sudbrack.

4.

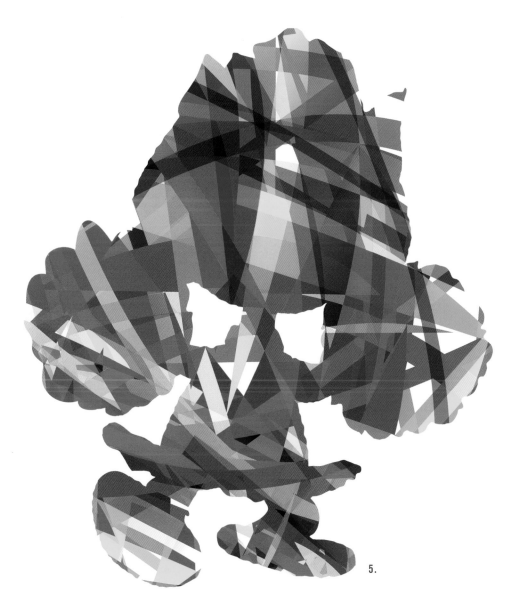

5.

show, AVAF stood for "Adderall Valium Ativan Focalin" because the work addressed the general contemporary problem of the individual oppressed by the city and the subsequent anxiety that keeps people awake at night.

Although Sudbrack tackles some tough topics and at first seems to take an in-your-face approach, he strives to create work that that welcomes the viewer from any culture, gender, age, color, or nationality. It is his "will," he says, "to attract you in a very positive, very warming way. I'm not trying to trick you: I want the outcome to be positive. I want the total sensorial experience of my work to be uplifting."

Schulz said something similar about his own work: "There's a communication there, a bringing of joy, a bringing of happiness without being too pompous about it. I simply like to draw something that is fun." Despite the

trials and tribulations that Charlie Brown and the rest of the gang undergo, everything turns out okay. In the end, happiness *is* a warm puppy—a notion that evidently has universal appeal. Sudbrack embraced this philosophy and set out to create Peanuts art that "comes nearest to the uplifting moment," as he puts it, and that will engage kids and adults of all stripes.

Color, for Sudbrack, is the key to achieving universality. "I've always believed that color has a unifying power," he says. "Color brings people together, color is universal. I use it as a tool in my work to bring people in so that they relate immediately to it." He is not intimidated by an art world that he perceives as being somewhat prejudiced against color, an element that many think is superficial, he explains. For him, it's the opposite in its facility to provide depth and context. It is something

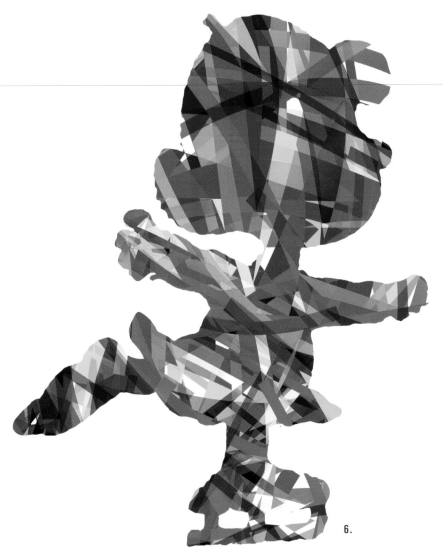

6.

that he remembers his father (a poet, who encouraged his flair for art) told him, "Color is present in whatever you do." From his earliest doodles to his work today, Sudbrack's work erupts with color that acts as his universal language.

Growing up in Rio de Janeiro, Sudbrack fell in love with Snoopy and the rest of the Peanuts gang from the comic strips in his local newspaper. When he finally convinced his mother—who convinced his father—to get

him a dog, he named it Snoopy. The fact that the dog was not a beagle, but a poodle—and a very large one at that—mattered not at all. Sudbrack's familiarity with Peanuts from the newspaper, not from television or books, left him with the memory of it in black and white. For an unabashed colorist, this initially presented a challenge.

Another challenge came from what he remembered as chronically static characters (except, of course, that

"I've always believed that color has a unifying power."

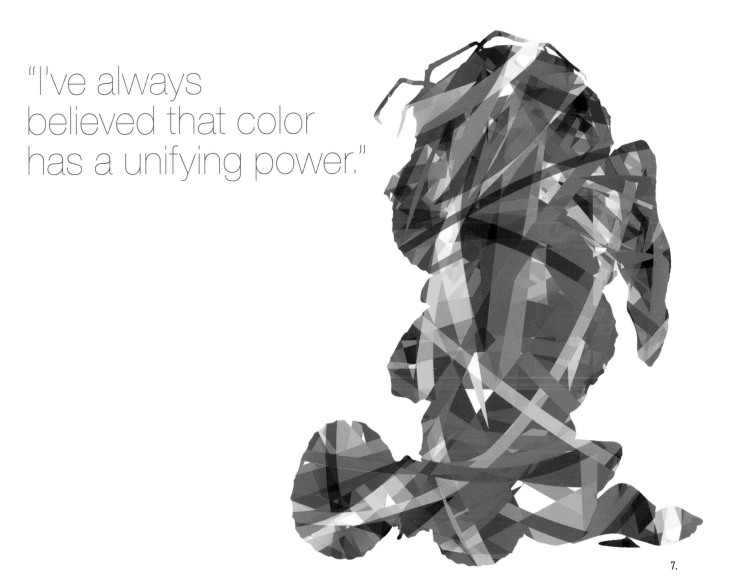

7.

audaciously adventurous beagle). Sudbrack's ingrained impressions were of the characters standing relatively still, often in profile, with activity limited to conversation. But digging through the archives, he was reminded that they did break out into sporadic bouts of dancing, ice-skating, and tumbling—"lots of tumbling," he recalls. "Whatever happened, they would tumble." The tumble (somersault) was a physical response to just about everything, but yelling in particular. When Lucy yelled at Charlie Brown, or Schroeder, or any of the other characters that she was frequently admonishing, demeaning, or

otherwise reprimanding, they somersaulted backwards. Linus would tumble, entangled in his blanket. Pig-Pen would kick up a swirl of dust and dirt as he went over and over.

Tumbling became the mandate. "I want to make the Peanuts gang explode and dance in a different environment, outside the comic strip. I want to liberate them, activate them," he says. AVAF morphs again: Access Vivid Action Fun or Activate Vivid Action Friends or Access Vivacious Activity Freedom, or Activate Varied Adventure Fun or . . .

FIGURE 6: "Lucy makes me angry," says Sudbrack. "She's so annoying." Nevertheless, he does have a certain fondness for Lucy on skates, striking her grand, slightly imperious stance as if she is saying, "Behold the greatest skater of all," he says.

FIGURE 7: Vibrant colors may not be the obvious choice to depict gentle Linus, considered the philosophical conscience of the gang, but "vibrant colors can mean different things," states Sudbrack, "although people don't often relate them to different elements. Here, I felt that the contradiction matches."

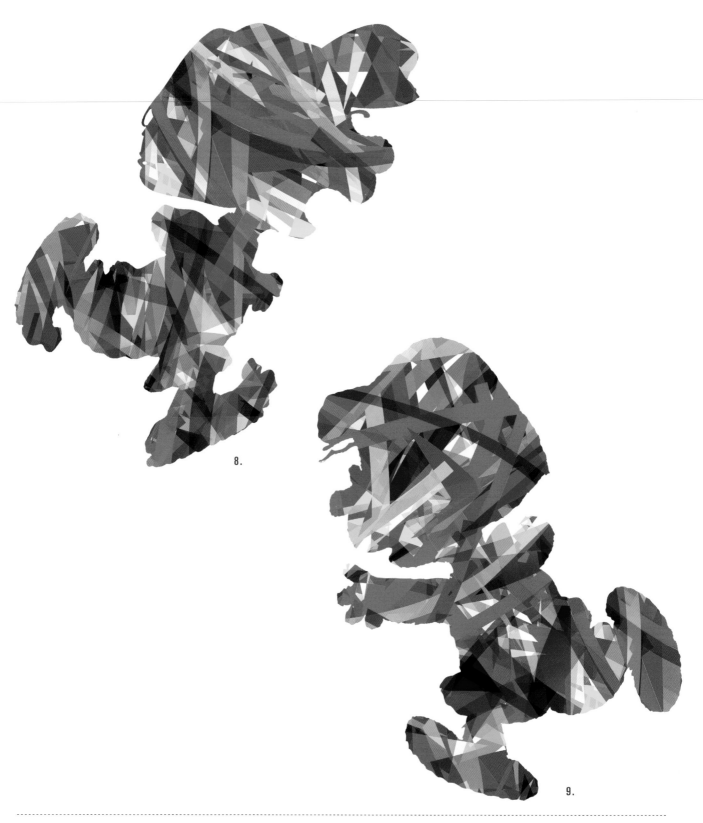

8.

9.

FIGURE 8: Transgender issues have repeatedly been a theme in Sudbrack's oeuvre, so it is fitting that Peppermint Patty, called "Sir" by her sidekick, Marcie, would be his top favorite along with Snoopy. "I had to depict Peppermint Patty running and screaming. That is totally how I picture her," he says. "I loved the fact that Peppermint Patty is always spaced out at school, but has this other side—the sporty, spunky, active side. And I always imagined she and Marcie as girlfriends."

FIGURE 9: Unlike Lucy with ice skates on or Linus with his blanket, Sudbrack didn't recall a signature image for Marcie. "What I do recall is her always with glasses, and always running after Peppermint Patty," he says.

FIGURE 10: "When was Schroeder not at the piano?" asks Sudbrack, who confesses that this was an easy one. Nevertheless, the artist did have to pay careful attention to proportion and is himself a bit surprised that the young musician's intensity is evident, even through the layers of pattern.

FIGURE 11: When he first dug into the project, Sudbrack immediately thought of the familiar iconography, such as Charlie's Brown's home telephone, the not-so-Great-Pumpkin, Schroeder's piano, and, of course, Snoopy's home. "Initially I had thought about not doing the characters at all, but, of course, I couldn't resist them," says Sudbrack.

THE WORK

Sudbrack's initial approach to Schulz's characters was to "create landscapes in which they would be in action," he says. In place of Schulz's line and minimally delineated facial features, he gives the characters unmistakable outlines and profiles: Charlie Brown's bowling ball of a head, Snoopy's prominent proboscis, Schroeder's C-curved body at his wee piano, Linus clutching his blanket, and so forth. The shapes are filled in with strips of color that become the dominant motif in the series, set against backgrounds that are whirligigs of various shapes and forms.

But it started with tumbling. In one of the first pieces he worked on (Figure 12), the characters are tumbling within thought bubbles. The background design and the palette, which the artist envisions being rendered in fluorescent color, is close to the abstract paintings that currently line the walls of his Rio studio and will be the focus of his upcoming show there. Here, he employs bigger shapes of color that are "not so crazy and full of details," as in his other work, he explains.

The same, quieter background is also on display in Figures 13 and 14, in which the characters are dancing against a background comprised of only eight shapes. However, here the gang is sporting clothes that show the signature pattern that is used throughout Sudbrack's series. These geometric strips of color inject the scene with exuberant warmth that reverberates with action.

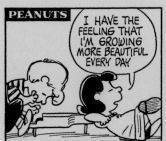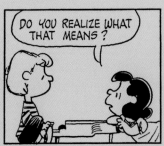

FIGURE 12: "They were always tumbling. When someone would shout at Charlie Brown, he would tumble. Whatever happened, they would tumble."

"I want to communicate that vibe you have when you're roller-skating—that you're free and liberated."

FIGURES 13-14: Sudbrack borrows from his current abstract work and employs a simpler background to create a composition that is "not so crazy and full of details."

13.

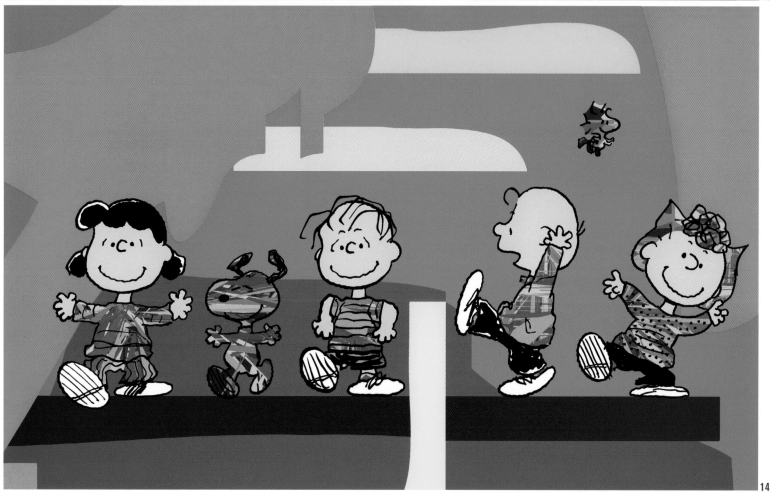

14.

FIGURE 15: Here, the gang holds their dancing poses from the previous image, but Sudbrack ratchets up the kineticism with a background of a swirling rainbow of ovals.

FIGURES 16–17: These two pieces exemplify Sudbrack's building technique of figure + pattern + more pattern.

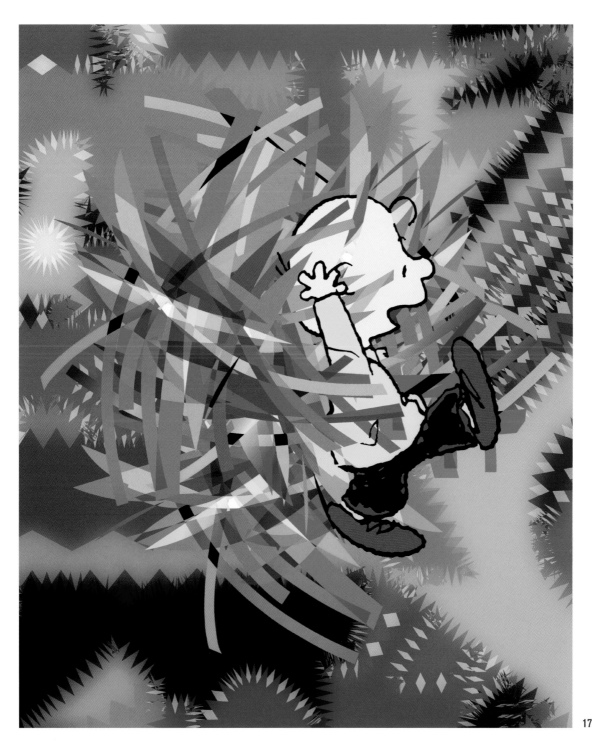

17.

This kinetic approach is even further exaggerated in the designs (Figures 16–20) that Sudbrack hopes will become a Peanuts-themed roller-skating rink, a type of public art project with which he has already been engaged. New York's Central Park was home to the first of AVAF's artsy rinks, which were re-created in the Miami Beach art district's Faena Forum and other locations throughout the state.

Figures 16 and 17 show two stages of the design process. In Figure 16, Charlie Brown is seen dancing, kicking up a leg encircled in a swirl of color. Then we see this set image against a different background pattern that displays larger, contrasting swatches of color and shape. Snoopy is set against an array of dynamic backgrounds in Figures 18, 19, and 20. The peripatetic beagle is depicted in a variety of activities—ears bending

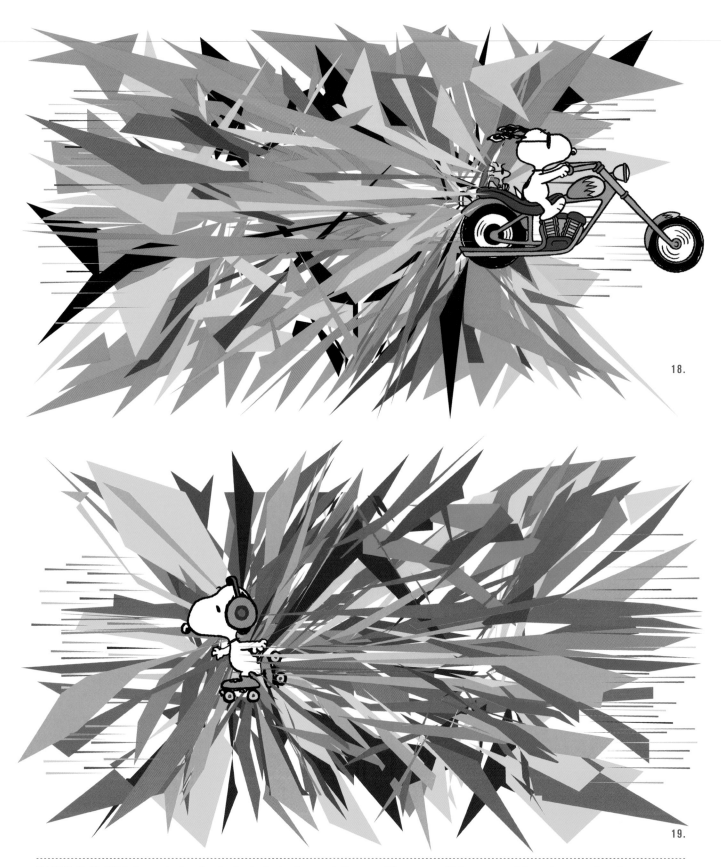

18.

19.

FIGURES 18–20: With dynamic shards of color in the background, Snoopy all but races off the pages as biker, skater, and surfer.

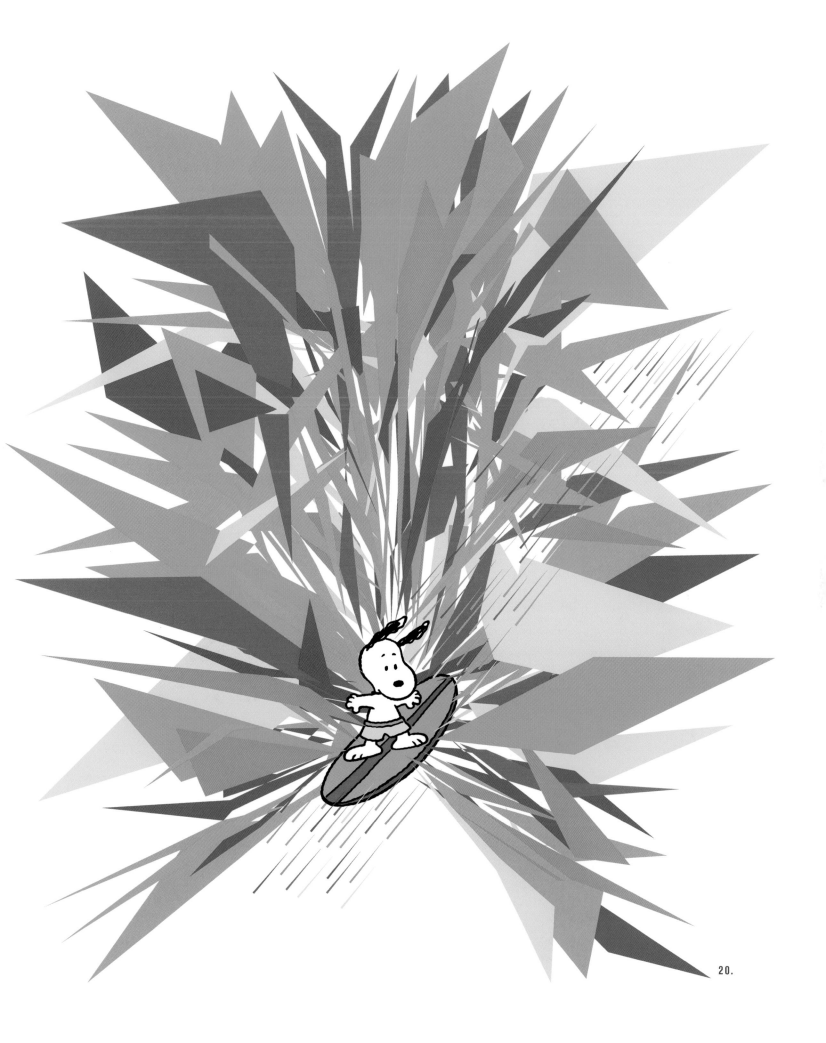

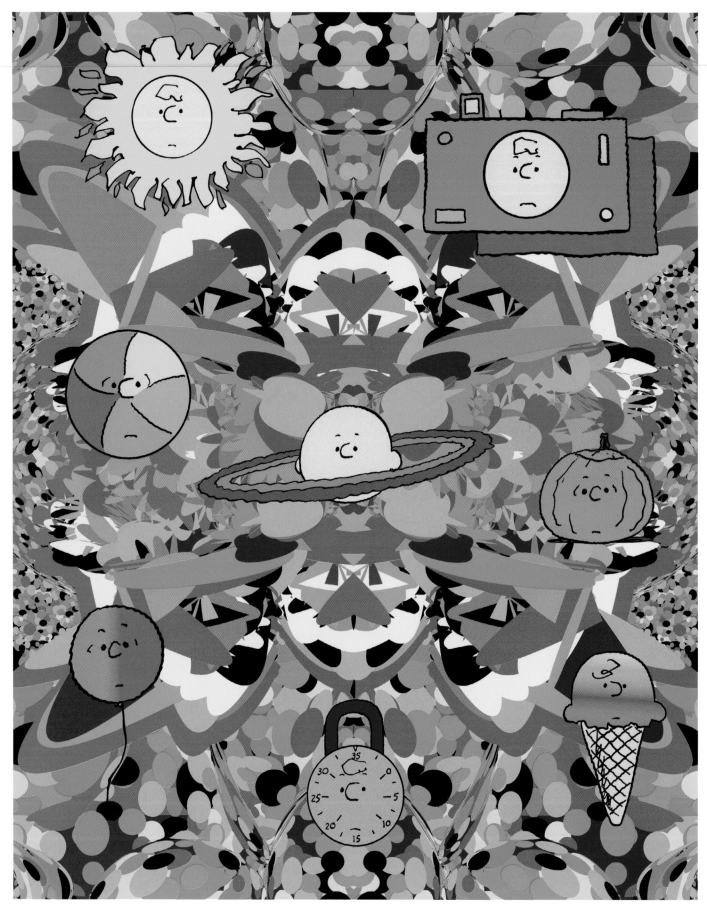

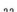

this way and that, or covered with headphones in the image of Snoopy actually on roller skates—a rare find among the many ice-skating images. Sudbrack imagines skaters gliding over the images, looking down at them as they skate. "I want to communicate that vibe you have when you're roller-skating—that you're free and liberated," he says.

In other designs (Figures 21 and 22), Sudbrack has adopted a surrealistic approach to the characters and their familiar props. His research revealed that some of Schulz's larger works were introduced with transmutations of the characters: Charlie Brown as an ice cream cone, for example Figure 21. Sudbrack has gone further in all-over compositions, in which Peppermint Patty and Marcie are a pair of pens; Snoopy's grin is

a tree; and an entire kind of "Charlie Brown solar system" of transmutations in which he is variously the sun, Saturn, a camera, a pumpkin, a beach ball, a combination lock, a balloon, and an ice cream cone (Figure 21). In Figure 22, Sudbrack has removed the characters altogether, instead juxtaposing icons in whimsical ways.

Extrapolation is a concept Sudbrack embraces in myriad forms, from his art becoming wearable apparel, to decals extracted from his wallpaper. One collector purchased a few of Sudbrack's individual decals and created his own unique installation with them. "Many artists would balk," Sudbrack exclaims, "[but] that was fantastic for me! My work is not precious. I want it to be the trigger of everything and be inclusive, and not focus on my personality."

FIGURES 21-22: The figures reflect Sudbrack's surrealistic rendition of Peanuts through transmutations of the characters and props, creating a "Charlie Brown solar system," as he calls it.

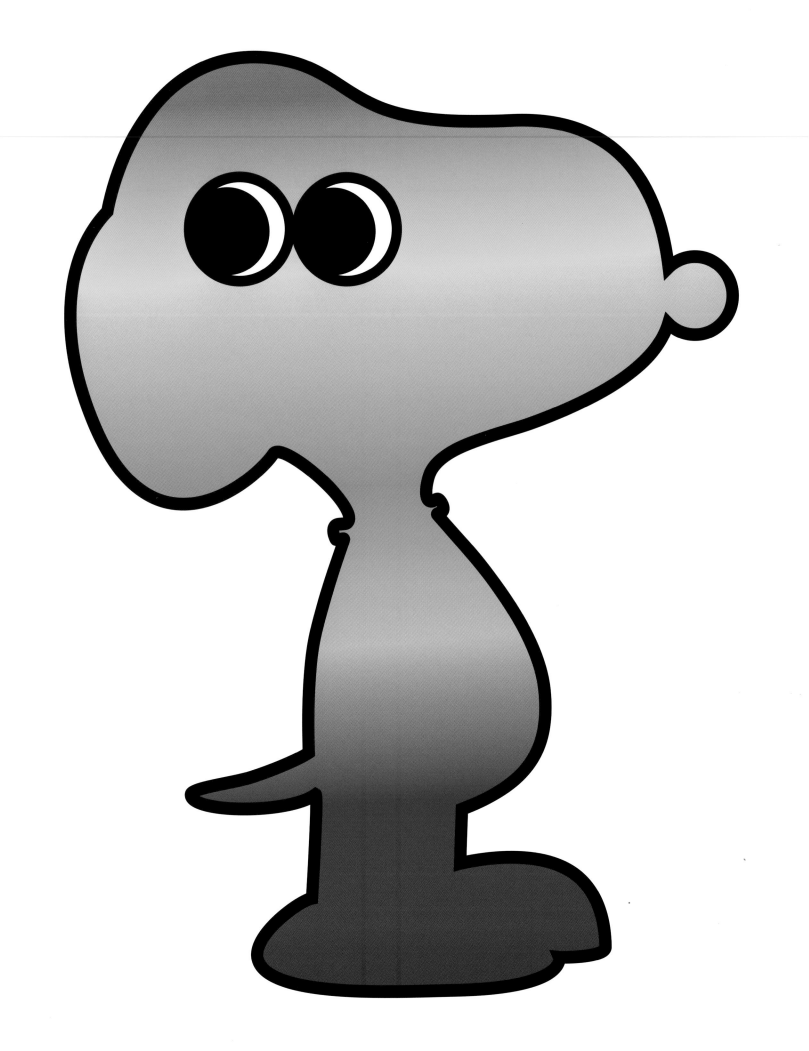

"EVERYONE UNDERSTANDS PEANUTS BECAUSE THEY WERE THE CUTEST EVER."

— SAM + TURY

In 2002, **SAMUEL ALBERT BORKSON** and **ARTURO SAN-DOVAL III** became friends with each other when they began their collaboration to explore experiential art across a variety of media, under the moniker Friends WithYou. Now they want to be FriendsWithYou and everyone else on the planet. Borkson, born and raised in Plantation, Florida, and Sandoval, born and raised in Havana, Cuba, met on a dance floor in Miami and joined forces with the sole purpose of "spreading the positive message of Magic, Luck, and Friendship."

Both easily admit to sharing a sense of not having to be an adult. "We are not pressured into adulthood like a lot of our friends are, because we are still playing with toys and making toys—activities that are not allowed in an adult," they say. This sense of whimsy, integral to both their personal and artistic characters, is evident in all their work, from their collaborations with musician and producer Pharrell Williams to their experiential art installations all over the world in which they "invite audiences

into a magical world where the line between imagination and reality is blurred." It also obviates the reason they were eager to reimagine the work of Schulz, whom Sandoval sees as an artist who captured the essence of the human condition—endlessly yearning for the loss of childhood.

In 2016, FriendsWithYou's *Super Moon*, a 20-meter moon-shaped balloon, floated on Seokchon Lake in the southern part of Seoul for a month. It appeared every day, in seven colors, from an hour before sunset to 10 p.m. Its round face was animized by three curved lines—two shallow U-shaped eyes and a tiny nose. The work is characterized by the two foundations of the duo's work: animism and poetic reduction. FriendsWithYou uses animism to show that "we are just these beings inside these human bodies, but we could be so much more . . .

FIGURE 2: Borkson and Sandoval want to be FriendsWithYou and everyone else on the planet.

2.

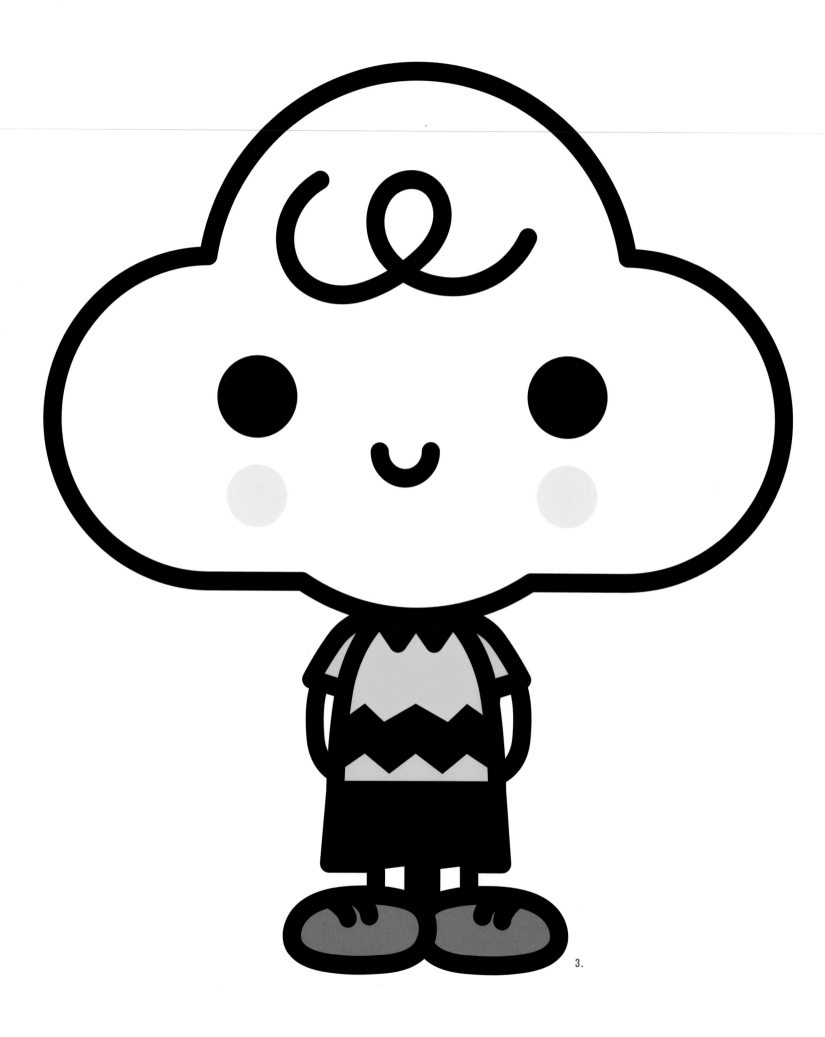

3.

The strength of all art "lies in its reduction to its most potent idea. Thus all art is poetic reduction."

We could be the air around us, the clouds in the sky, and the plants and trees and animals all around us. It's hard to see it sometimes because of the human ego being what it is."

The tool they use to express this idea is a graphic language that approaches poetic reduction. The strength of all art, they believe, "lies in its reduction to its most potent idea. Thus all art is poetic reduction." By comparison, Schulz's own "only what's necessary" method of reduction may have been the result of the syndicate that published him early and the necessity for him to shrink the size of his strips in order to save precious space on the newspaper's page. Nevertheless, like FriendsWithYou, it's part of Schulz's genius that allowed Charlie Brown to express every human emotion with only four lines.

Little Cloud, FriendsWithYou's most familiar image, is a close cousin to good 'ol Charlie Brown. Simple in size, shape, and detail, Little Cloud became the standard bearer for the artists' language, which embodies the positive mantra of peace, of being and doing anything you want, and—most importantly—of always having a friend. "In our mission to teach the world that everything is FriendsWithYou, we put an animistic face on a cloud to show that even the clouds are alive," says Borkson of Little Cloud, comprised of nothing more than a puffy shape and three lines—one representing a smile. "We are hard-wired to mimic," they say, so "when you see something smiling at you, you kind of have to reciprocate," added Sandoval.

Little Cloud is animized; Snoopy is anthropomorphized. Few would argue that Little Cloud and Snoopy speak a universal language of irresistible cuteness, comfort, and security. It's no surprise, then, that growing up, Borkson was "super in love with Charlie and Snoopy and that whole world."

FIGURE 3: "We put an animistic face on a cloud to show that even the clouds are alive."

Even as a child, Borkson felt that Peanuts spoke to kids, as it expressed a kind of melancholy that told children that they don't have to be happy all the time. The artist had a difficult relationship with his parents and a troubled home life, and found comfort in Schulz's creations. He vividly recalls one of the many Peanuts specials that he watched on TV, *Snoopy, Come Home*, in which Snoopy and Woodstock run away and frolic happily while harp music plays in the background. As early as 7 years old, Borkson fantasized about running away from home and striking out on his own. "My parents even said to me, 'If you could have had an apartment at 7, we would have let you,'" Borkson recalls.

It's not surprising, then, that Borkson would be drawn to a strip where there is nary a parent, teacher, or other adult authoritarian figure in sight. Shortly before he died, Schulz described how, as the creator, he controlled "all these characters and the lives they lived. You decide when they get up in the morning, when they're going to fight with their friends, when they're going to lose the game. Isn't it amazing how you have no control over your real life?" he asked. It was the empowerment that the

FIGURE 4: Sandoval is attracted to the idea that Snoopy is visualized in a reduced graphic language, but still lives the life of a regular kid.

Peanuts gang possessed that so appealed to Borkson. Peanuts captured the sense of loneliness that results from always "being under" your parents and teachers, as Borkson describes it, and the resulting joy of getting out from under adult authority.

Sandoval's early associations with Peanuts were very different from those of his partner. Growing up in Havana, Sandoval had little exposure to Peanuts in any form, but did see the Christmas special when he was a child. "It always stayed with me. It captured the quintessential elements of what a perfect little existence it would be to live in the United States," he says, and adds that it served as a kind of nostalgia for what it would have been like to grow up in the U.S., as opposed to Cuba.

Sandoval is attracted to the idea that Snoopy is visualized in a reduced graphic language, but still lives the life of a regular kid—living in a house, playing with friends, and, of course, imagining all manner of personae. "Our work is related to that. The language we've created speaks to everyone."

Working on their own, artists go off on tangents, they explain. It's something they find beautiful and amazing, but "at some point, the work has to appeal to a lot of people. It can't be grand ideas that are just personal delivered in a single tone—they have to be archetypical and relate to everyone."

That being the case, they point out that the long-accepted division of high and low art—of majestic but esoteric art versus art that appeals to all—is a thing of the past. "All art is equal," Borkson declares. "Hierarchy is fictitious and is falling apart as we speak," noting that when Schulz created Peanuts, it was a far less accepting environment, in which comics were considered a lower form of art. "But, not now, and that's a breath of fresh air," he adds.

"Our mission [is to] teach the world that everyone is FriendsWithYou."

They have the luxury of living in a time when they can be unabashed in their role as "two men who create sweet things like cute clouds. Cute is disarming. It's punk for us. We love not being angry and apathetic and pissed like so much of the art world," says Borkson, certainly an attitude reflective of Schulz's. When biting satirical cartoonists like Garry Trudeau came on the scene with strips like *Doonesbury*, boldly expressing particular

points of view, Schulz remained neutral, only with occasional bouts of very subtle political and social commentary. FriendsWithYou goes even further in their quest to "talk to the whole world." Devoid of snarkiness, satire, politics, and didacticism, the art of Borkson and Sandoval has a single clear mission: "To teach the world that everyone is FriendsWithYou." Said in Schulzian terms, "Happiness is a warm puppy." And like Schulz, Borkson and Sandoval understand how a reduced graphic language is the easiest way to communicate this cozy and comforting idea to multiple, multicultural generations. "Everyone understands a smiley face, everyone understands a cloud," Sandoval says. And everyone understands Peanuts because they were "the cutest ever," they agree.

FIGURE 5: Little Cloud, Sleepy Moon, Chuck, and Snoopy are here to say, "When you're stuck, we're FriendsWithYou."

FIGURE 6: An upside-down bird, a bouncing head, and the animized cloud are all following a beagle who walks on two legs in an odd but joyous parade. "It's about owning your own weirdness," says Sandoval.

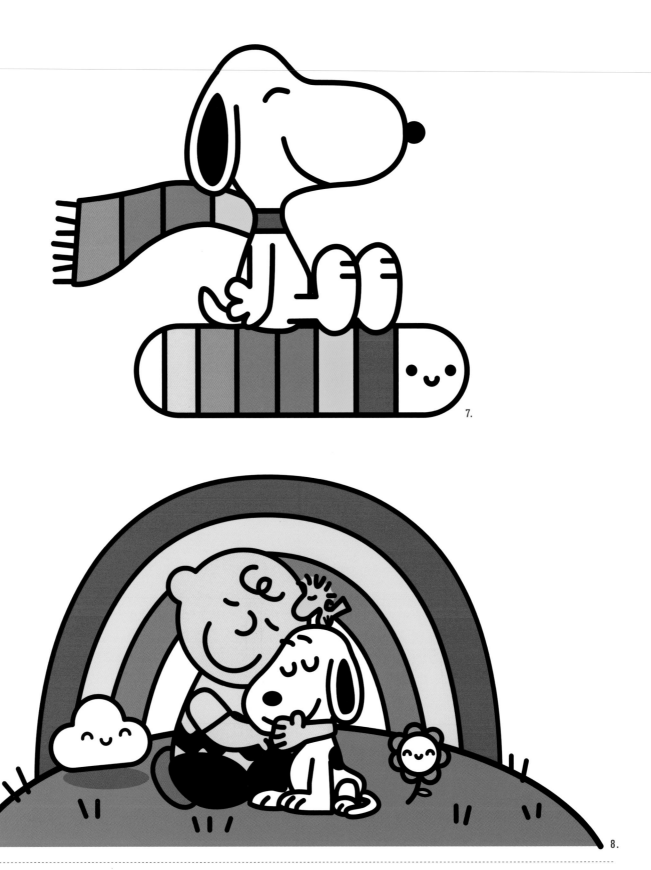

FIGURES 7–9: "We've taken rainbows and made them more of a universal, beyond symbolizing gay pride and the LGBTQ community. When you see a rainbow, it's so special."

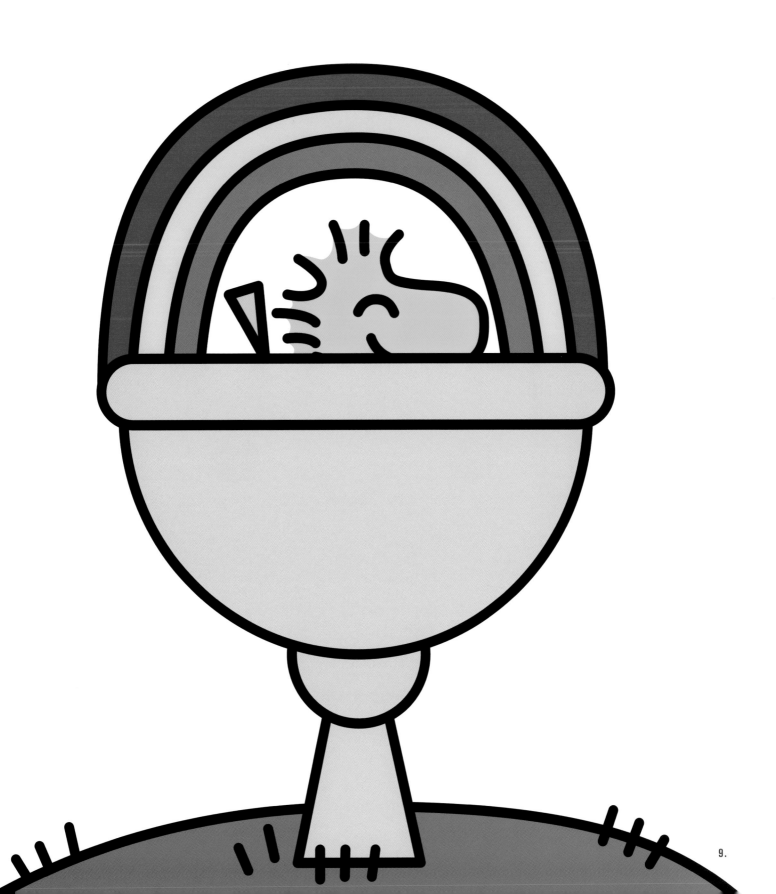

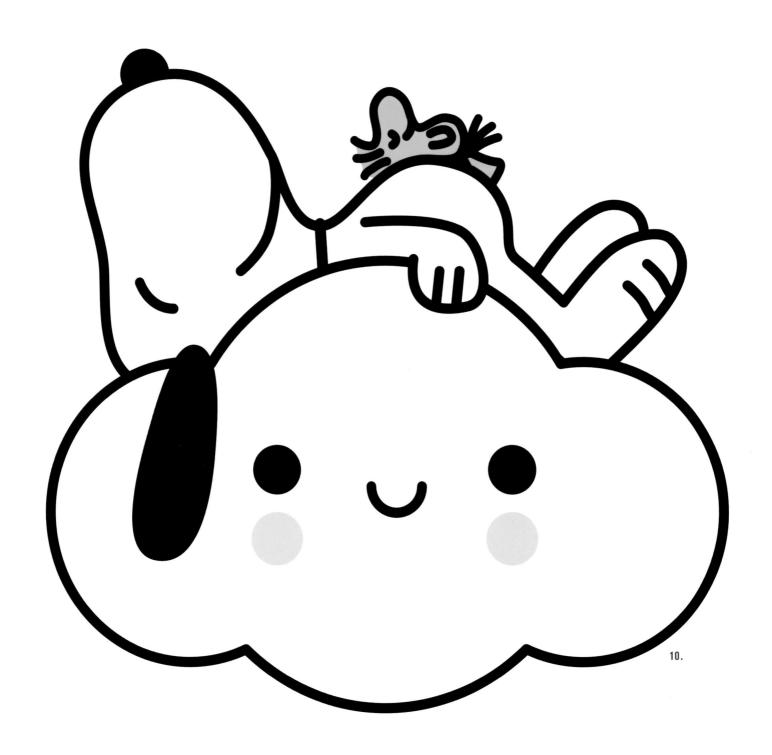

FIGURE 10: "Once we had this cute sandwich of Snoopy and the cloud, from there, there were tons of places to go."

10.

THE WORK

Beyond a shared sensibility, there is much that is similar in the process and graphic qualities of FriendsWithYou and Schulz. Both use a minimum number of lines to create a series of repeated characters and images. What is "only what's necessary" for Schulz is "poetic reduction" for Borkson and Sandoval, and they manage through this minimalist approach to create stories that pack an emotional punch.

But simplicity can be deceiving, and still waters run deep, thus Borkson and Sandoval were careful to respect the emotional weight and the teachings of the Peanuts characters. They approached each graphic as if it were a sentence that revealed as much about how the characters felt as it did about what they were doing or saying. Sandoval points out that Snoopy, his house, Little Cloud, and their sleepy moon all hold emotional power. "We're sure that Snoopy saw the house as a friend, the grass as a friend. So, we turned Snoopy's house into a character. For us, putting Snoopy on top of our Little Cloud, on top of this archetypal reference point, was the clearest starting point for us," he explains. "Once we had this cute sandwich of Snoopy and the cloud, from there, there were tons of places to go."

Cute is more than just cute for Borkson and Sandoval. It is a way they communicate friendship, kindness, and love. "Being cool is over; being loved is what we need," they declare. "We need an extra helping of just being compassionate and understanding, and being loving toward each other."

While no one would accuse Schulz of being harsh, Sandoval and Borkson softened the tone even further and added that "extra helping" of compassion and understanding by introducing fluffy Little Cloud. In Figure 11, Little Cloud becomes the house, with Snoopy and Woodstock in their familiar positions sleeping on top

of it. The image announces that Little Cloud is welcome, too. That it's not about Snoopy's house as an object, it's about the idea of home, where all are welcome.

Fighting, war, and aggression would never be part of the FriendsWithYou world, so they've given Snoopy's

FIGURE 11: "We're sure that Snoopy saw the house as a friend, the grass as a friend."

FIGURE 12: Rather than depicting the Red Baron as the World War II fighter pilot, FriendsWithYou imagined Snoopy fighting for goodness and love and the humanism that Little Cloud represents.

11.

12.

PEANUTS by SCHULZ

CONTACT!

HERE'S THE WORLD WAR I FLYING ACE HIGH OVER ENEMY LINES IN HIS SOPWITH CAMEL..

WHAT'S THAT? A FOKKER TRIPLANE DIVING DOWN OUT OF THE SUN!

IT'S THE RED BARON! HE'S RIDDLING MY PLANE WITH BULLETS!

I LEAP FROM THE BURNING AIRCRAFT..

7-18

I DASH MADLY ACROSS NO-MAN'S LAND TO SAFETY AND THE AERODROME..

THE GENERAL IS SURE TO AWARD ME A MEDAL FOR MY COURAGE! MAYBE THE BRONZE STAR!

HEY, WHERE HAVE YOU BEEN? I'VE GOT SOMETHING FOR YOU...

THE BRONZE SUPPER DISH!

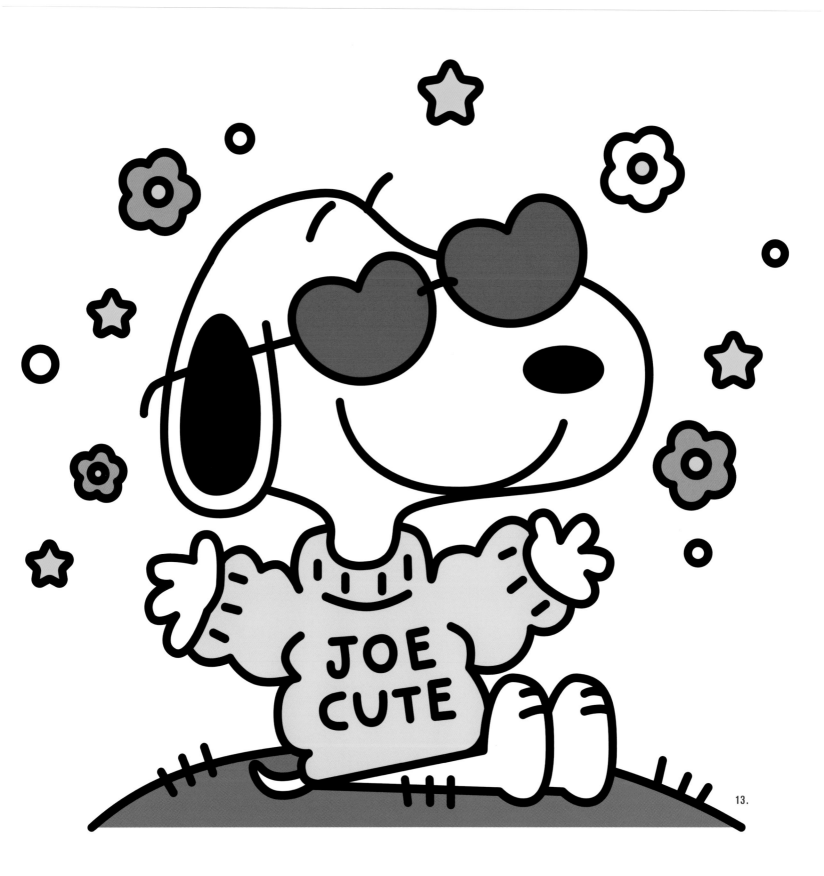

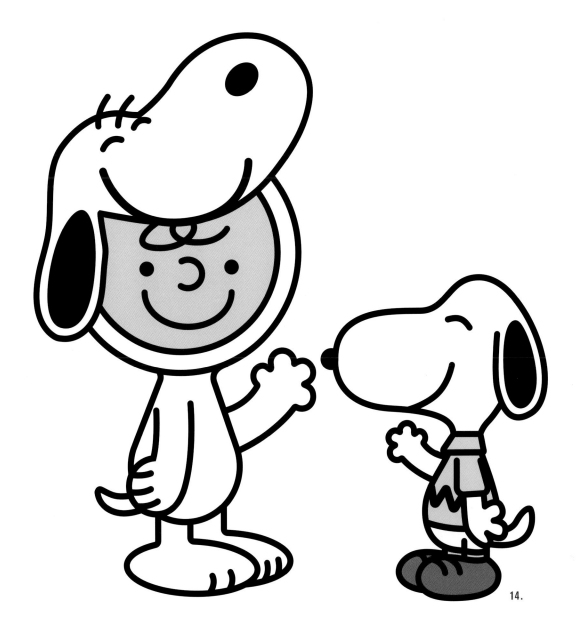

14.

alter ego, the Red Baron, a twist (Figure 12). Although Snoopy still wears his fighter pilot fatigues, Borkson and Sandoval have swapped out the bright red doghouse with Little Cloud to communicate that Snoopy is fighting for goodness and love and the humanism that Little Cloud represents.

Since "being cool is over," Joe Cool, one of the most familiar and popular guises of Snoopy, presented a bit of a conundrum. But the artists found a solution (Fig-

ure 13). They loosened up his fitted "Joe Cool" sweater to make it "a big fluffy sunny-colored sweater made for hugging," as they describe it. And they've replaced the words "Joe Cool" on the sweater with "Joe Cute." Suave Snoopy still exudes a bit of cool, but the message is that everyone is welcome to hug him and be cool, too.

"Of all the imagery, there's a lot of dialogue going on in this one," says Sandoval, referring to Figure 14. Charlie Brown is universally identified by his bright zig-zag shirt, and an astronaut was one of Snoopy's very familiar guises. But here Sandoval and Borkson have mixed that up to express another important tenet of their work: "We don't have to be identified as one thing," says Sandoval. "We can be whoever we want to be."

FIGURE 13: Schulz's Joe Cool becomes Joe Cute with a "fluffy, sunny-colored sweater made for hugging."

FIGURE 14: "We don't have to be identified as one thing," says Sandoval. "We can be whoever we want to be."

"FOR OUR GENERATION, PEANUTS WAS . . . ALMOST LIKE THE BIBLE, IT WAS FOR EVERYBODY."

— TOMOKAZU MATSUYAMA

TOMOKAZU

MATSU

"Growing up, it wasn't so much that I was a fan of Peanuts, but rather Peanuts was my reality, like going to school," says **TOMOKAZU MATSUYAMA**, better known as simply Matsu. He says that in Japan, knowing and enjoying Peanuts was as routine as "Asian kids eating rice. . . . For our generation, Peanuts was bigger than pop culture. It seemed like it had been there forever and would always be there. Almost like the Bible, it was for everybody."

But when Matsu was growing up in Gifu, Japan, he wasn't thinking much about comics or art. His mind—and body—were on the nearby ski slopes, where he honed his snowboarding skills and went pro at age 21. He dominated the sport in Japan until an accident, which resulted in a complex break of his ankle, abruptly ended his sports career and left him unable to walk for nearly a year.

"Suddenly, I had a lot of time to think about my whole life looming before me. 'What do I do now?' I was forced to ask myself," recalls Matsu. So, he took a typical route

of his contemporaries and attended Tokyo's Sophia University, where he studied business. Then he visited New York, and his world fell off its axis. "The worst decision I ever made was coming to see New York a little bit," he jokes. He enrolled in a two-year program at the Pratt Institute, where he earned his MFA in communications design, after which he produced "deadly boring annual reports and other dreadful corporate brochures," as he describes them.

The drudgery was short-lived. For the first time in his life, Matsu mixed and mingled with contemporaries who were pursuing art full-time as a combined avocation and vocation. The realization that art could be a career—

--

FIGURES 1-2: Playing upon the silhouette concept we see in Figures 8 and 9, Matsu has morphed the characters into ink blots without losing their recognizability. Matsu has also cleverly worked Charlie Brown's iconic yellow shirt with the black zig-zag into the composition by using bits and pieces of it throughout the painting. We never actually see the shirt, but we instantly recognize the imagery.

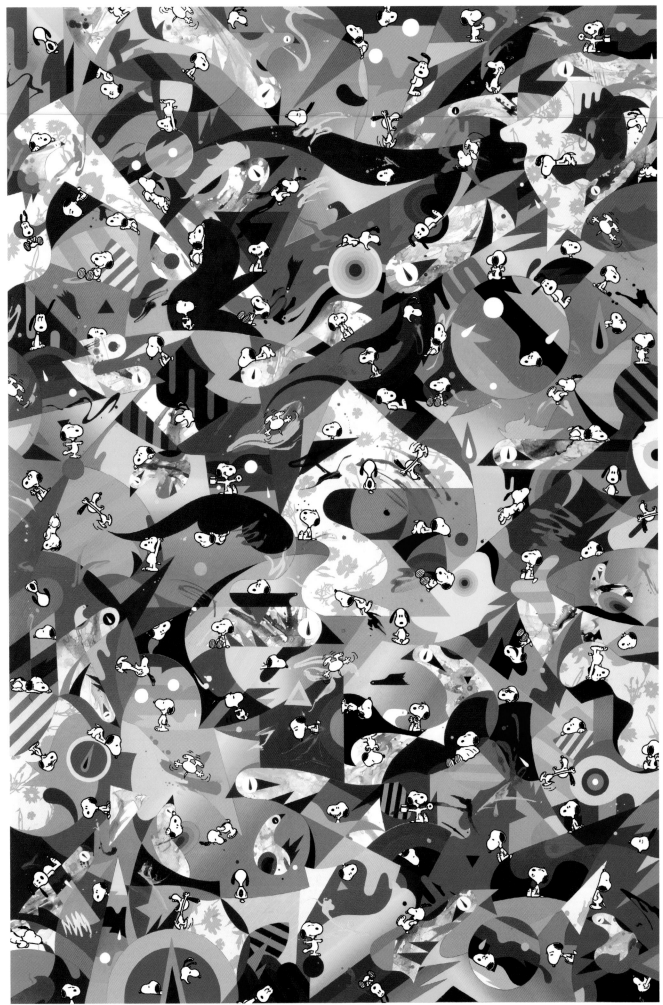

"There is no story, no narrative ever in my paintings! It is for the viewer to make up his own story."

one as exhilarating as speeding down the side of a mountain—changed everything for Matsu. With no formal art training, Matsu took his cues from the likes of Jean-Michel Basquiat, Keith Haring, Andy Warhol, and the earlier artists of the Pop movement. But what defines his work is a mashup of these 20th-century American artists with the art and culture of Japan. Matsu lives at the intersection where global pop culture, art, and Japanese tradition and history collide.

Matsu appropriates many different images from national treasury paintings of Asia to manga, from Victorian and Baroque wallpaper patterns to traditional Japanese textiles. "I bridge opposing aesthetics from different histories and regions, blending them with my visual vocabulary until it becomes mine." His work expresses a

FIGURE 3: The first thing we see is signature Matsu—a busy, all-over composition bursting with color, shape, and pattern. But upon closer examination, Snoopy is everywhere, engaged in every possible activity, from sliding down a curve that recalls Snoopy surfing, to his classic skater pose, this time on top of a red ball instead of on the ice.

range way beyond "East meets West," a phrase he disdains for its sentimentality. "Diversity is not a statement, it's a fact," he says. "I disregard the elements of age, gender, East, West, contemporary, traditional, conceptual, or decorative. I really want to hit the gray zone."

So for Matsu, the idea of reinterpreting the works of Schulz in his own artistic language was an easily digestible concept; the challenge was to get the blend just right. "From beginning to end, I thought, 'How do I avoid too much of me or too much Schulz,'" says Matsu. There were other challenges as well. Matsu is an unabashed colorist who maintains a library of more than 5,000 Pantone colors that he mixes for his work. All of Schulz's 17,897 comic strips were created with black ink on white paper.

The point of tension between Matsu's work and Schulz's is that, unlike Schulz, Matsu eschews storytelling. "There is no story, no narrative ever in my paintings!" he says. Instead, he creates what he calls "fictional landscapes" in which "it is for the viewer to make up his own story."

[65]

While Schulz's work is masterful in its simplicity, Matsu's captures what he calls the "organic chaos" he sees in how cultures collide in his kaleidoscopic compositions rendered with a vast and voluptuous color palette. Schulz's had to be simple. By definition, a comic strip is spare and has a beginning and an end. A story must be told in tiny spaces measured in inches, with no room for repetition or excessive detail. The handful of panels with a paucity of words is the total work of art. The way to look at a comic strip is preordained—left to right, one panel at a time, one text bubble at a time.

Matsu's works are neither spare nor small. They are large, vibrant compositions that reverberate with pattern and color, rife with repetitive elements: hundreds of cherry blossoms, multitudes of figures, dozens of varieties of lush leaves. Matsu answers Schulz's "only what's necessary" with "*everything* is necessary."

--

FIGURE 4: Matsu answers Scultz's "only what's necessary" with "*everything* is necessary."

There is, however, a point of intersection between Schulz and Matsu, and it is the one thing that is the most essential ingredient for both of them—drawing. Far less obvious in Matsu's work, it is nevertheless the foundation of everything he does. His paintings reveal thousands of components, figures and shapes, flowers and patterns, trees and snow, that he manipulates many times before he settles on the final composition. But the drawings remain the inviolable underpinnings of his work. Matsu's foundational pencil drawings are always on hand while he's at work on a painting, sometimes even tacked to the canvases, and remain the essential DNA of all of his art.

While Schulz's alphabet is small, comprised of a set number of characters, one or more who are featured in each work, Matsu draws from a limitless vocabulary of possibilities, both organic and inorganic, representative and abstract, sourced from the real world as well as figments of his febrile imagination. But it all begins with a drawing.

FOR THE LOVE OF PEANUTS

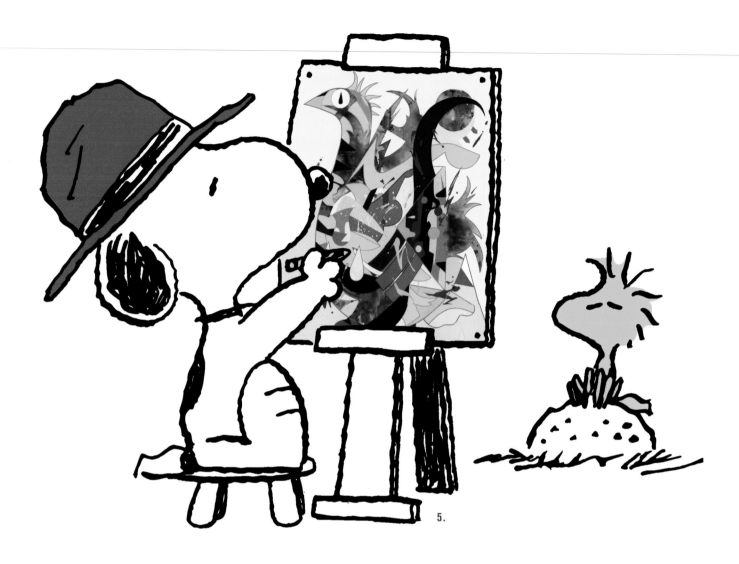

5.

THE WORK

While Matsu strove to strike the right balance between Schulz and himself in his Peanuts work, the scale tips back and forth. Figure 5 is a reimagining of a single panel of Schulz in which he depicts Snoopy painting a portrait of Woodstock that hews very close to the original. Matsu found the original hilarious and thought, "What would happen if Snoopy were painting a contemporary, abstract portrait of Woodstock?" So instead of the rudimentary stick figure–like the rendition of Woodstock in the original, Matsu has created a colorful bird–which looks nothing like Woodstock–buried in a wild display of feathers and other elements.

In contrast, in Figure 6, a fine example of one of Matsu's "fictional landscapes," the viewer needs to look closely to find the incorporation of anything Schulz. But even before we notice Charlie Brown and Snoopy,

--

FIGURE 5: Closely hewing to Schulz's original image, Matsu offers his own interpretation of Woodstock, as told through Snoopy.

"What would happen if Snoopy were painting a contemporary, abstract portrait of Woodstock?"

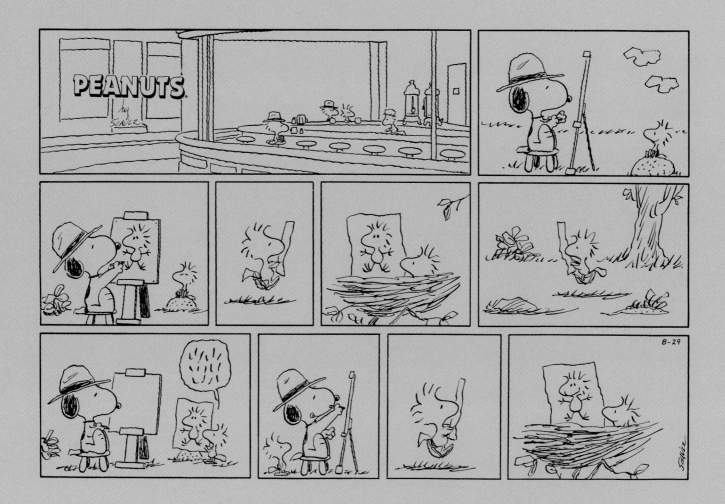

partially hidden in fear, at the base of the trees in the lower right corner, there is a something about this painting that seems to reflect a very familiar Peanuts scene. And, indeed, it does. The simply drawn, leafless and scrawny trees, and the snowflakes dotting the canvas, are inspired by the celebrated television special *A Charlie Brown Christmas*.

Sticking to form, Matsu is not giving us a story, but one can't help but wonder why Charlie Brown and Snoopy look nervous, if not outright terrified by the horses with their riders. And what about the flowers? Matsu leaves it to the beholder to write the narrative.

Horses did not figure into Schulz's work, but here they exemplify Matsu's layering of history in his work. He is referencing the venerable tradition of equestrian portraiture, in which the authority of monarchs, noblemen, and heroes is depicted by the control they exert over their swift-moving animals. Matsu references the work of Jacques-Louis David, specifically his 1801 masterpiece, *Napoleon Crossing the Alps*, as well the works of

FIGURE 6: In this typical Matsu "fictional landscape" in which Charlie Brown and Snoopy are supporting actors, Matsu has blended elements of French neoclassicism, the art of the American West, and 1960s television comics iconography. "In every culture you look into, classical and traditional painting featured horses and riders," he says.

American artist Frederic Remington, whose heroes were both cowboys and Native Americans. "In every culture you look into, classical and traditional painting featured horses and riders," he says. In signature Matsu style, he has brought together French neoclassicism, the art of the American West, and 1960s television comics iconography in a work that with its complexity, color, and detail is all his own.

Matsu's style is also dominant in Figure 7, which showcases his use of floral and leafy patterns, whose origins can be found in Victorian and Baroque wallpaper patterns, as well as in traditional Japanese textiles. Charlie Brown is near the center figure, looking rather perplexed, while Snoopy sleeps soundly in the lower right, and the Woodstock next to Charlie Brown holds a flower. Perhaps Charlie Brown is pondering the snow that seems so out of place amidst the verdant foliage and bright flowers. Or perhaps he's wondering where Snoopy is. Or who this strange person lurking behind him is. Again, the story is in the eye of the beholder.

The snow would be quite out of place if not for the reference to the Christmas special, but it frequently appears in Matsu's work. "I started to paint snow and weather because I wanted to capture motion," says Matsu, "something that is hard to paint." He adds that weather makes a scene—or the figures in it—more nomadic, and gives the compositions a whiff of sentimentality.

FIGURE 7: Charlie Brown looks quite perplexed against one of Matsu's typical snow-sprinkled, floral, and leafy backgrounds, whose origins can be found in Victorian and Baroque wallpaper patterns. "I started to paint snow and weather because I wanted to capture motion, something that is hard to paint," says Matsu.

8.

Figure 8, Matsu agrees, is where he comes closest to the perfect balance of his and Schulz's styles. Matsu set out to maintain the integrity of the characters, but "because the characters are extremely strong and so familiar, I wanted to find a way to loosen them, without losing them," he says. In studying Schulz's drawings, he noticed two key factors: one, that it is the line that dominates the characters, and two, that even just the

FIGURE 8: Here, there is a near-perfect balance of Schulz and Matsu. "Because the characters are extremely strong and so familiar, I wanted to find a way to loosen them without losing them," says Matsu.

FIGURE 9: Ribbons of pink have been added to the comic-book-like composition to break up the grid. The randomness of the streaks add an element of the abstract to create a more all-over feel.

9.

silhouettes, without facial expressions, exude tremendous emotion.

Matsu created a grid, which suggests the panels of the strips, but added his own color palette and removed the actual lines, re-creating them through shape. "Schulz's images are so familiar that people can instantly reference the shapes. To identify the silhouette of Snoopy is a no-brainer," says Matsu. "It became this minimal, contemporary piece of art," he says, "in which the whole idea was to approach it in a minimalistic way, but exaggerate by eliminating." So we notice the shape of the text bubble, without the shape; we see Snoopy in action that is made clear through the shape of the silhouettes, not facial features. We see typical Peanuts strips, but they are not really there. We see Matsu's complex and colorful all-over composition, but it's not there, either. It's an oxymoron—it's a pure hybrid. "And," as Matsu says, "hybridity in the place where we live now."

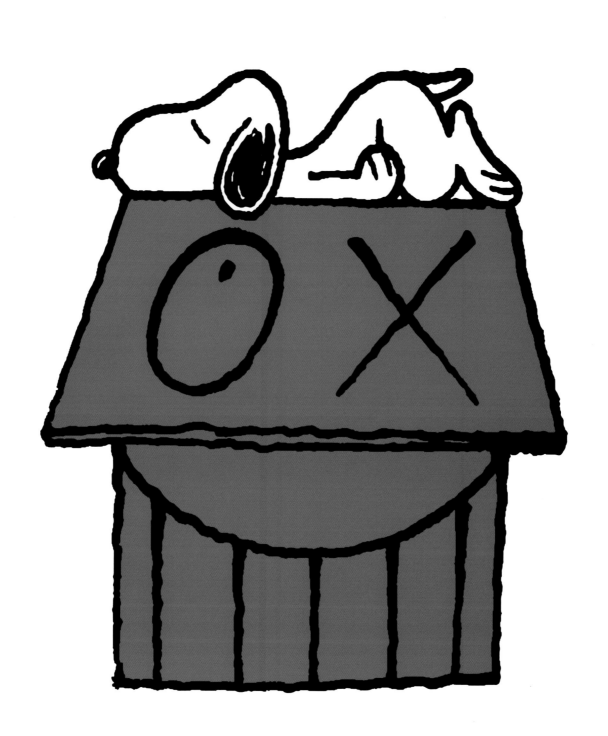

"PEANUTS IS A WORLD WHERE YOU BARELY SEE THE ADULTS AND IT'S ALL ABOUT THIS FREEDOM WE HAVE WHEN WE ARE KIDS."

— André

André Saraiva—**MR. A**—is many things: a graffiti artist, an installation artist, an international hotelier, a night-club entrepreneur, a restaurateur, and a partier with the A-list. He's the kind of guy that attracts the "in crowd"; they swarm him like bees around honey. But he is not a snob, nor does he care much about material things. "I don't really own a house. I don't have a car. I like people more than things," he said in a 2013 Times Talk.

This carefree and peripatetic adventurer began as a graffiti artist in his early teens. Born in Uppsala, Sweden, Saraiva moved to Paris with his family at the age of 10. "I couldn't speak French. I had to find my way so I started to draw a lot," he says. "I always had this little tendency to write on walls. I used to paint on the walls of my room, my mom's apartment, and the walls of the school."

Later, when he started to do graffiti all over the world, he found that it a wonderful way to discover a place. When he went out at night to paint, he would get lost. Adopting Hansel & Gretel's technique, he would find his way home by passing back along the graffiti that he had just painted.

His first graffiti tags, as is common in street art, were his name. "But then I thought it wasn't a language that everybody could understand," he says. So, he turned his attention to creating a character who represented every manner of expression and feeling. In 1994, Mr. A was born. His graffiti alter ego has a round head, with an X and O for eyes; a toothy grin; two long, spindly arms; and similarly rendered legs that can bend, twist, and reach as far as they need to—even with their pointy shoes attached. A classy dude, Mr. A often sports a top hat, an accoutrement that Saraiva added to bring "a little idea that he was a gentleman," he says. Less deliberate was the influence of a comic book, *Mandrake the Magician*, that Saraiva read as a child. "Mandrake was a superhero magician who had a top hat, and Mr. A's a bit of a magician," he says.

FIGURE 2: Just as Schulz adds a baseball cap to Charlie Brown, Saraiva will sometimes adorn Mr. A with a top hat . . . but nothing more.

Charlie Brown Snoopy & woodstock & Mr. A.

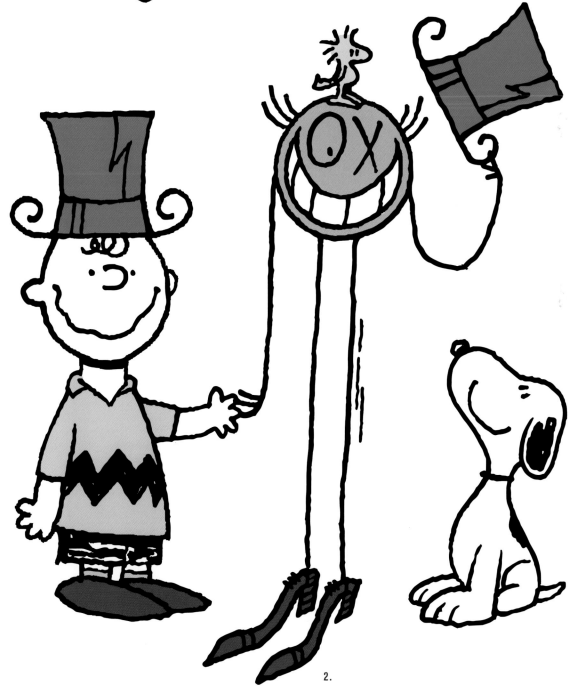

SNOOPY & MR. A

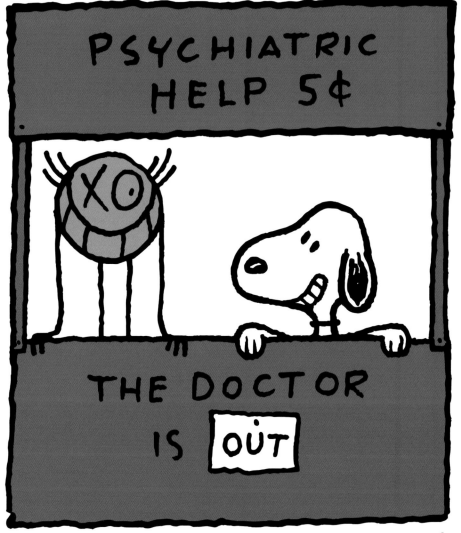

"We live in a world where people like to define you and put you in boxes."

At the time Saraiva introduced Mr. A to the public, the idea of using a character as a form of graffiti was completely new. "Graffiti was all about letters, but not so much about a figure that could talk to everyone," he said in his Times Talk. Since then, he estimates that he has drawn Mr. A as graffiti well over 100,000 times. Now, after more than two decades since the birth of Mr. A, Saraiva feels compelled to draw on paper—and does so at least 10, and sometimes as many as 30, times a day. But, although graffiti is a much riskier venture these days, he still manages to keep Mr. A in public view.

He certainly doesn't need to maintain his street status—his multifaceted art projects have been shown in galleries and museums around the world. As a night-club owner, his entrepreneurial talent made clubs such as Le Baron and ParisParis huge successes. He also holds shares in the Hotel Grand Amour in Paris and was the art director of *L'Officiel Hommes* magazine from 2011 to 2015. Saraiva disregards categories. "We live in a world where people like to define you and put you in boxes. Oh, you are a painter or you are a graffiti artist or you are a club owner, do movies or photography. I try to do all those things because I am curious. I enjoy doing that. And I don't make separation from all these different activities."

In the mid 2000s, he launched a commercial project, *Love Graffiti*. For $2,500, a customer could commission Saraiva to spray-paint the name of a beloved in pop-colored bubble letters very near or at their exact address, so that the name couldn't be missed.

FIGURE 3: Saraiva found Lucy's psychiatric booth a very adult element in a world notably without adults. Snoopy's mischievous grin might imply that he and Mr. A are up to no good while Lucy is away.

In 2016, in the heart of Lisbon, Saraiva completed a two-year project in which he created a 10,000-square-foot tiled wall in the Azulejos tradition, which dates back thousands of years. Saraiva put his contemporary stamp on the 50,000 tiles with colorful fantasy scenes of cityscapes, seascapes, rainbow skies, and, of course, Mr. A.

But graffiti is who he is. "I think graffiti gave me this freedom to do things, to not wait for people to like it, approve it, give me their permission. I do things because I feel they're right, because I feel it tells a story, and I do many things in different fields."

Peanuts definitely felt right to Saraiva. Growing up in Sweden, his mother subscribed to a comic magazine called *Charlie*, named after Charlie Brown, "and I of course I devoured them," he says. He continued to read Peanuts books, known in Europe as "Snoopy books,"

during his childhood, and says that "later in my career I became really interested in Schulz's drawings, process, and universe."

When he visited the Charles M. Schulz Museum and archives prior to beginning his work for the Peanuts Global Artist Collective (PGAC), he was amazed by the sharpness of the drawings and how Schulz made reference to some of the early American comic artists and their work, like George Herriman and his character Krazy Kat. Seeing Schulz's drawings from different eras and how the style of the characters changed slightly over time also intrigued him.

As Saraiva was working on his own Peanuts drawings, he realized how some of his lines and hand drawings were similar to Schulz's drawings. "It influenced me for sure, but in a very unconscious way. I realized I'd been unknowingly inspired by it."

Charlie Brown
Snoopy & woodstock
& Mr. A.

SNOOPY & MR. A

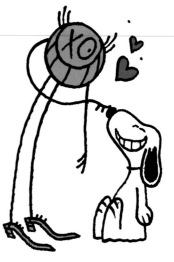

Snoopy ♡ Mr. A.

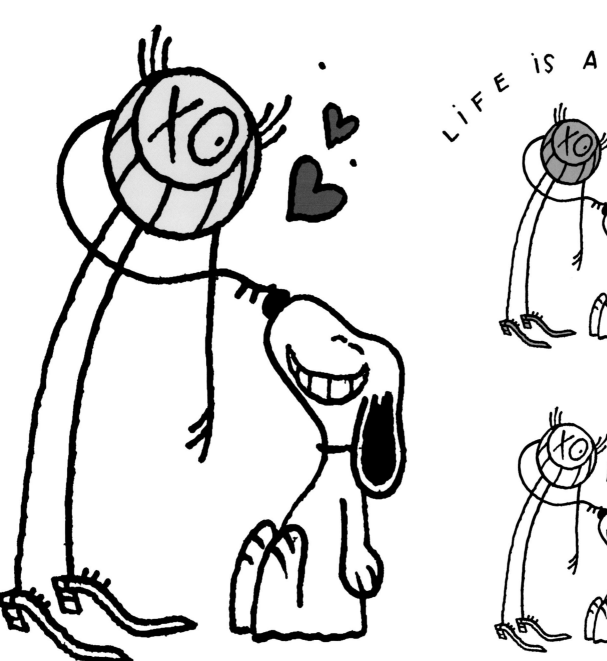

LiFE iS A DREAM

5.

THE WORK

For his Peanuts creations, Saraiva's process was simple—he used paper, a Japanese pen, and Chinese ink, echoing Schulz's straightforward drawing method. Like Schulz's characters, Mr. A is drawn with a limited vocabulary of symbols. But just as Schulz would add a baseball cap to Charlie Brown or sunglasses to Snoopy, Saraiva will sometimes crown Mr. A with a top hat, but never anything more than that.

Most of Saraiva's Peanuts works are in black and white, Schulz's foundational palette. It wasn't the imitation of Schulz that prompted Saraiva to work in black and white, but rather his own preference. "Often the black line on a white surface is more vibrant," he says. "It's a graphic way to transform the drawing almost into a language, because it's similar to text."

When Saraiva did add color, he stuck to only four: red, yellow, orange, and pink. Pink is characteristic of his work, including his early street art, although it is not commonly found in graffiti art. "As a guy doing my tags in pink, it was a bit of a provocation. But it became my color. Yves Klein had his blue, I had my pink," he says.

A very textual element is the X and O of Mr. A's eyes. In his early creations of Mr. A, the X was a way

FIGURES 4–5: "Mr. A is just very happy to have the chance to hang out with Snoopy," Saraiva says.

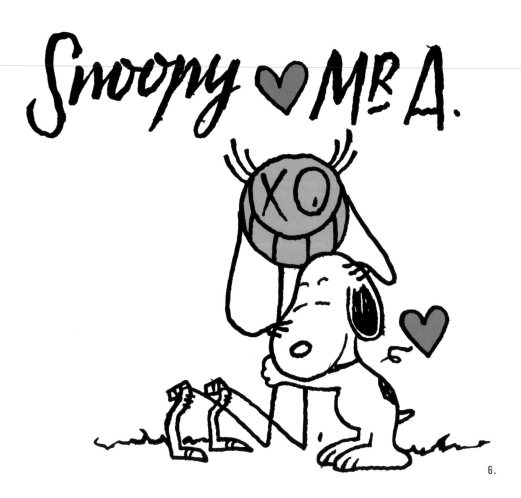

Snoopy ♥ Mr. A.

for Saraiva to indicate that Mr. A was winking. But over time, the meaning of the X and O has become more fluid; open to various readings. "It also can be a symbol for hugs and kisses, but sometimes it means he's half-awake, half-dreaming, or just that he lost one eye," muses Saraiva. "I invite everyone to interpret it however they want."

With more than 100,000 depictions of Mr. A, Saraiva's character approaches the popularity of Snoopy and Charlie Brown. But it's not a competition. "Mr. A is just very happy to have the chance to hang out with Snoopy," Saraiva says. Naturally, Snoopy and Mr. A would get along famously. Both are able to adopt many guises, and, more importantly, both project happiness, love, and acceptance. Saraiva has made this evident in his drawings by always having the two physically connected, from a tweak of the nose to a tickle, from cuddling to hugging (Figures 6 and 7).

FIGURES 6-7: The love among Snoopy, Mr. A, and Woodstock comes shining through in these images. Hearts circle the trio like butterflies.

7.

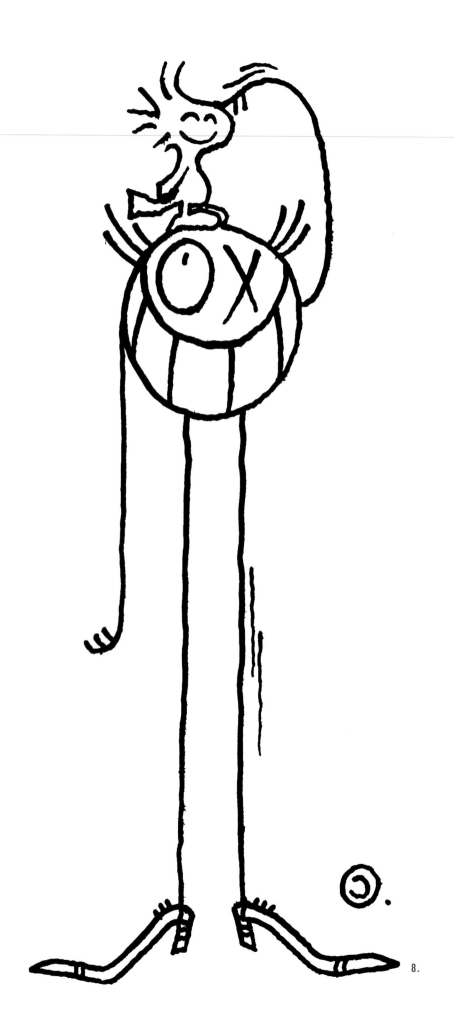

8.

SNOOPY CHARLIE BROWN & MR. A

And, of course, Woodstock, being Snoopy's best friend, joins the love fest, too. In fact, it is Woodstock who Saraiva thinks Mr. A is most like. "Mr. A must be from the same family as Woodstock," he says. "He must have some bird genes in him." In Figure 7, Woodstock sits atop Snoopy, who is in his familiar pose on top of his doghouse and, at the same time, hugging Mr. A. Hearts circle the trio like butterflies. Just Mr. A and Woodstock are seen in Figure 8, which shows Mr. A reaching up to scratch Woodstock's nose, turning his beak into a smile.

Throughout Saraiva's Peanuts interpretations, everyone is smiling all the time, even Charlie Brown, whose typical expressions of anxiety or frustration are nowhere to be seen (Figure 9). Saraiva depicts Charlie Brown and Mr. A sitting so contently against Snoopy's doghouse that they embody the idea of "soul mates." Mr. A's toothy grin has been replaced by a simple line, precisely mimicking Charlie Brown's. And Saraiva has forgone the X and O and used slight lines to indicate each eye, softening the boldness of the more textural approach.

FIGURE 8: Mr. A is most like Woodstock, according to Saraiva. "Mr. A must be from the same family as Woodstock," he says. "He must have some bird genes in him."

FIGURE 9: Throughout Saraiva's Peanuts interpretations, everyone is smiling all the time, even Charlie Brown, whose typical expressions of anxiety or frustration are nowhere to be seen.

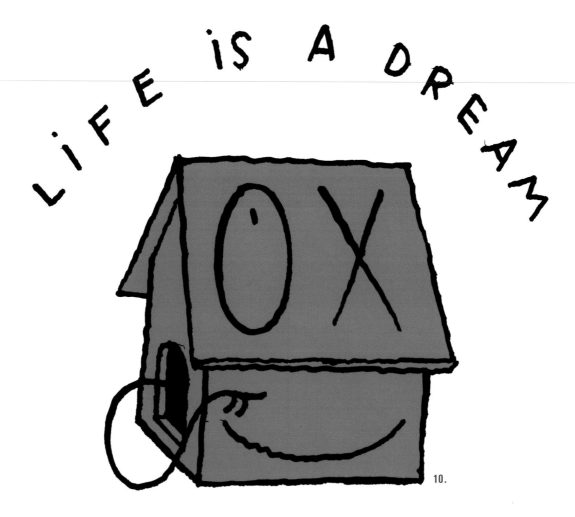

LiFE iS A DREAM

10.

Snoopy's house looms large in Saraiva's work because "[it] was maybe my favorite character, if a house can be a character," he says. "The red square of the comic strip was both a structure and a character," he explains. "The house is the link for the stories and sometimes a plane." Saraiva gives the house a new incarnation, in which structure and character are merged by making Mr. A become the house as well as inhabiting it (Figure 11). The O and X are integrated into the roof, while his toothy grin defines the front of the house. A different twist is seen in Figure 10, where the toothy grin has been replaced with a simple line for a smile and Mr. A's arm reaches out from inside the house. It has become his home, too.

Moving away from the love triangle of Snoopy, Woodstock, and Mr. A in Figures 2, 4, and 7, Saraiva has introduced Lucy's psychiatric booth in Figures 3, 12, and 13. "I always thought that the booth was a very adult element that those kids were using. Most kids would normally play doctor, rather than a psychiatrist," he says. Lucy isn't pictured. Either both Snoopy and Mr. A man the booth, or Mr. A alone. Explaining her absence, Saraiva says, "Lucy isn't in the drawing because Mr. A took over while she was away."

The adult nature of the psychiatric booth, with Lucy as the shrink, is just one Schulz's tropes that underscores the absolute dearth of adults in the Peanuts world. Saraiva says that this world without adults "is all about this freedom we have when we are kids." To Saraiva, for whom freedom is fundamental to everything he does in his life and in his work, Schulz is a comrade-in-arms.

FIGURES 10–11: "Snoopy's house was maybe my favorite character, if a house can be a character," Saraiva says.

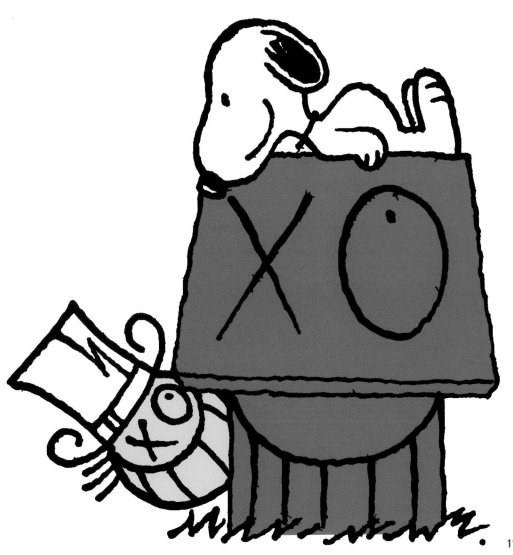

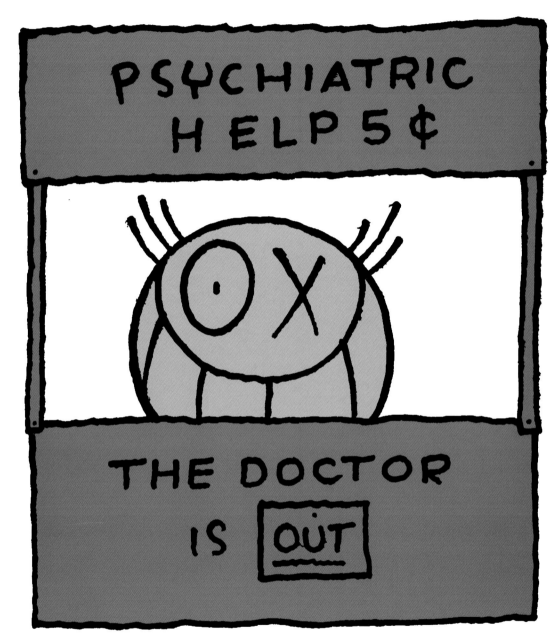

FIGURES 12–13: Mr. A mans Lucy's psychiatric booth alone. In Figure 13, Mr. A is reduced to only his signature O and X eyes.

SNOOPY CHARLIE BROWN & MR. A

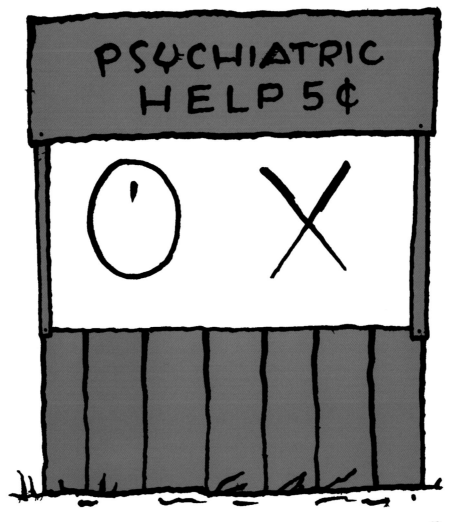

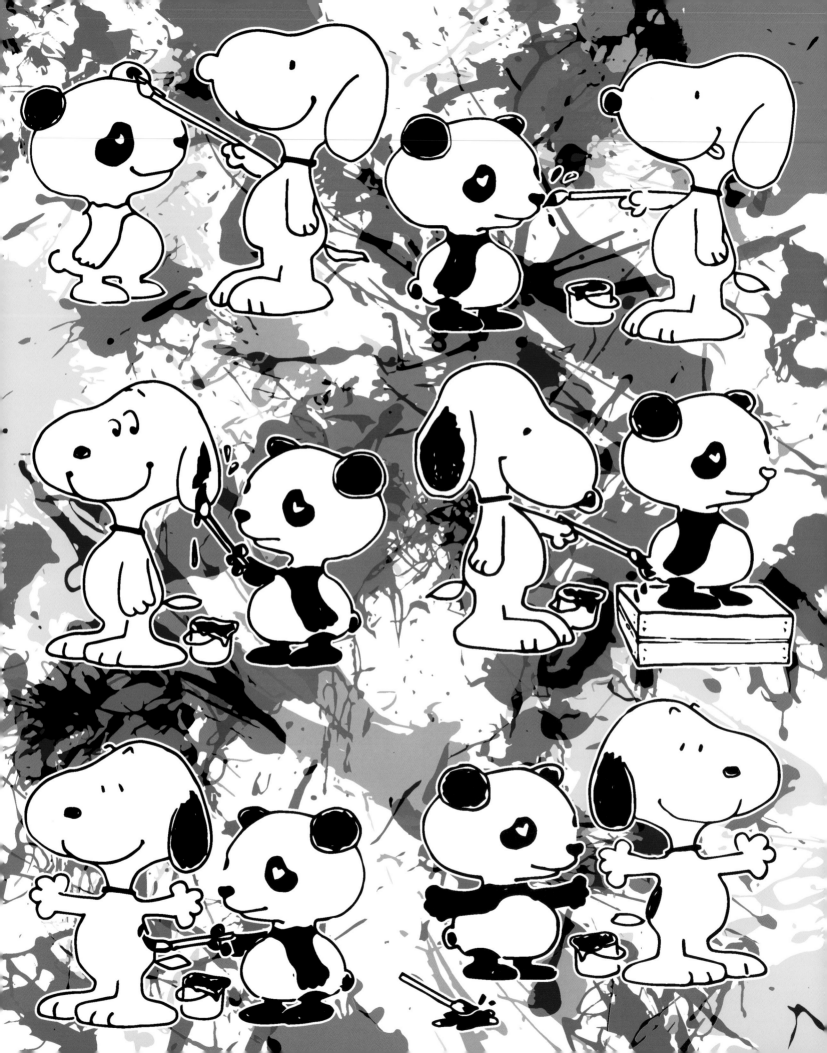

"I TAUGHT MYSELF HOW TO DRAW WHEN I WAS A KID JUST BY COPYING PEANUTS COMIC STRIPS."

— Rob Pruitt

ROB PRUITT

ROB PRUITT, a contemporary artist, considered a major figure in the New York art scene, says he taught himself to draw by copying Peanuts strips. "I probably still can draw all of them without looking," he says. That is just one of the reasons why it seems inevitable that Pruitt would become a part of the Peanuts Global Artist Collective, a project he says is "one of the first that I can remember that spoke to my sensibility." Since those early childhood days when he started copying Peanuts comics, Pruitt has had a fondness and appreciation for just about everything that Schulz represented in his art. He admires Schulz's reductive style of illustration and he likes the names of the characters, as well as the friendships and rivalries they had. "I like that every bit of it was an element of a cohesive universe. I like that the characters had fun times and, in the case of Charlie Brown, some neurosis about daily life as well," adding that Peanuts was highly formative in his early ideas of art and creativity.

FIGURE 2: Peanuts was highly formative in Pruitt's early ideas of art and creativity.

During his youth in Rockville, Maryland, in the 1960s and early 1970s, Pruitt would get his daily dose of Peanuts from the *Washington Post*. "But I was totally enthralled by, and committed to, the [TV] Christmas special, especially Vince Guaraldi's soundtrack and Charlie Brown's sensitivity toward the tree that no one else wanted." He was also struck by the commentary about commercialization run amok.

In a 2015 article in the *New York Times*, David Colman said that "Rather than denying that art and consumerism shared any border, Mr. Pruitt just bulldozed the wall between." Here, too, there is common ground to be found between Schulz and Pruitt. Pruitt describes his work as off and on being informed by commodities or things that are mass-produced for the marketplace, but not necessarily as a critique. "I was raised by parents who liked to go to the mall, even when they didn't need to buy anything in particular. For a lot of my youth, family time was spent cruising the aisles of department stores, just looking at things and dreaming about what we might get."

With the exception of the Christmas special, in which

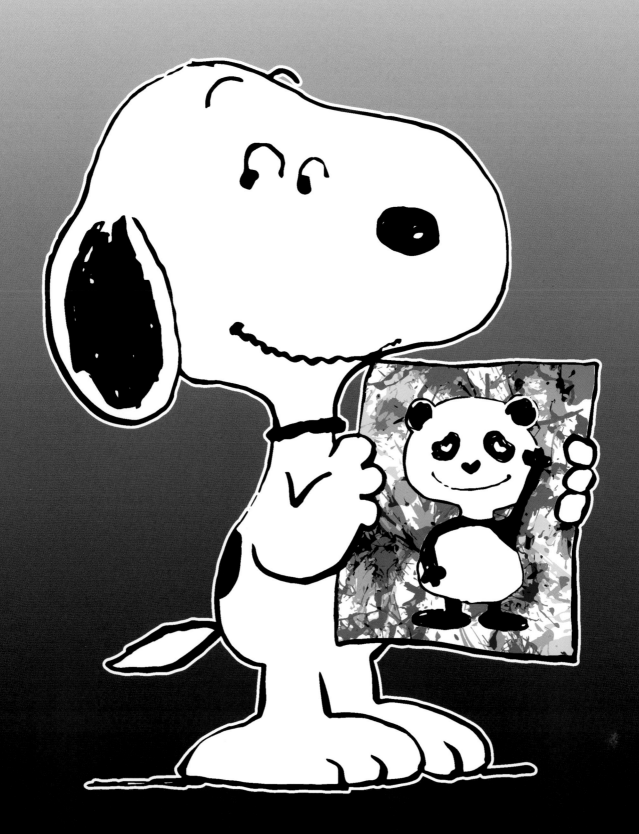

"I didn't want the panda to come between [Snoopy] and Woodstock."

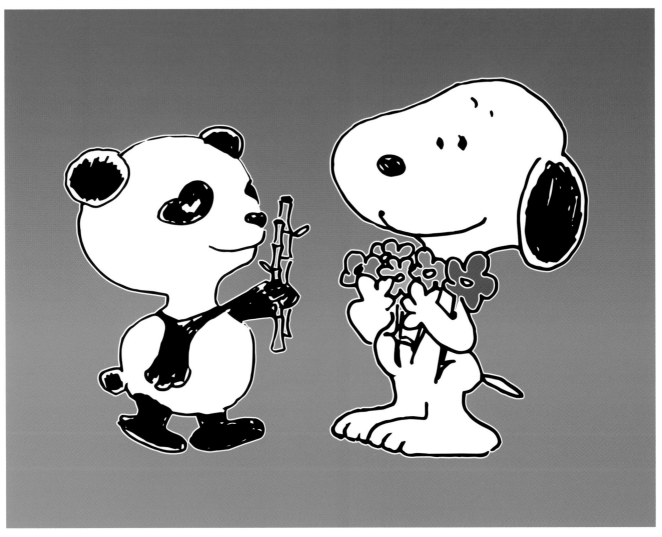

Schulz clearly critiqued contemporary culture's drive to overconsume, Pruitt doesn't necessarily view Schulz as an artist who constantly critiqued consumerism. Rather, Schulz's strips in and of themselves can be considered mass-produced commodities, as they were published in thousands of newspapers which subsequently spawned countless iterations of consumer products incorporating his art and design. Pruitt does not shy away from saying that "perhaps that is what interests me. I'm excited about some of the products that [PGAC] may generate."

Another commonality between Pruitt and Schulz is the ability to make people laugh. In Schulz's case, that was the point—he drew comics, after all. For Pruitt, as an artist whose reputation lies with the tastemakers of the gallery scene, to elicit humor is more surprising. Nonetheless, he succeeds. Ben Lima, writing about Pruitt in *D Magazine* in 2012, said, "Among countless artworks that try to be funny, Pruitt's are the few that can prompt an actual laugh out loud." His earlier work, says Elysia Borowy-Reeder, executive director of the Museum of Contemporary Art Detroit, "reveals a frisky sense of humor."

Pruitt has worked in various media from painting to installation, but what he is most widely and immediately identified with are his countless depictions of a panda. What the panda is for Pruitt is what Snoopy was for Schulz—an omnipresent figure that has a universal capacity to bring joy to the viewer.

Pruitt's panda, however, did not come from a particularly joyous place. In 1992, Pruitt and Jack Early, an artist whom Pruitt met while they were both earning art degrees at the Corcoran Institute in Washington, had a

FIGURE 3: The panda has brought a bouquet of bamboo to Snoopy, who, in turn, has flowers for him, putting a panda twist on Woodstock's frequent offerings of flowers.

show at Leo Castelli's SoHo gallery, entitled *Red, Black, Green, Red, White and Blue,* that was intended as a positive representation of popular black culture. The artists covered the walls in shiny gold foil, splattered them with paint, and displayed commercial posters mounted on obelisks of prominent black figures, including Michael Jackson, the Rev. Dr. Martin Luther King Jr., Jesse Jackson, and the hip-hop group 2 Live Crew. The scathing critical response to the show was so ferocious that it derailed Pruitt's career for several years. According to a 2001 article about Pruitt by Mia Fineman in the *New York Times,* "critics denounced the show as 'cynical' and 'degrading.'" Pruitt and Early were accused of racism. Their intention had been to point out the commodification of black heroes by predominantly white-owned companies, but, "at the time, the art world was very sensitive to identity issues and political correctness, but you could only be an authority if you were talking about who you were and where you came from," said Pruitt in the article.

Out of the ashes, the panda arose. Working as an art handler for a New York gallery in the 1980s, Pruitt was intrigued by the repetition of motifs in the work of so many artists. Years later, in 1998, still reeling from the Castelli catastrophe, Pruitt made a decision to paint

--

FIGURE 4: Pruitt allows Snoopy and the panda to symbolize the individual and group friendships of Schulz's Peanuts gang.

pandas over a period of five years. "I thought it would be an exercise in poking fun at repetition," he told Kelly Crow in the *Wall Street Journal*, "but I got really into it because I learned I could actually tell endless stories with the same image." That, and the pandas offered an opportunity to win back fans. "Who doesn't like pandas?" he asked.

And who doesn't like Snoopy? When the invitation came to Pruitt to collaborate with PGAC, he says, "I was thinking a lot about all of the friends that exist in the strip and my own artistic alter ego of the panda and how the panda might enter the social group, and, if so, who would the panda pair off to be best friends with? And Snoopy seemed like a great candidate, even though I didn't want the panda to come between him and Woodstock. Maybe one day they will all go river rafting together."

Long before this project came along, Pruitt had incorporated Peanuts into his 1999 exhibition *101 Art*

FIGURE 5: "I thought the panda would like strawberry and Snoopy would like chocolate, so they are both spinning on a strawberry-chocolate donut."

Ideas You Can Do Yourself, an acclaimed project that was conceived to teach his parents what conceptual art is. "They paid for my education and supported me through something that they really had no true understanding of." He created a recipe-style book filled with instructions for art-making, such as "Make a painting on a lampshade," and "Draw yourself into your favorite comic strip." The exhibition consisted of 35 of the DIY ideas fully realized, and among them was the artist himself in a Peanuts strip.

While it's easy to draw parallels between Snoopy and the panda, there is another even more striking area of intersection between Pruitt and Schulz that is found in Pruitt's gradient face paintings of 2013. Just as Schulz imbued Charlie Brown with a panoply of human emotion through the most minimal lines, Pruitt does the same in his face paintings. Indeed, Schulz's renditions of Charlie Brown were exactly where he drew the inspiration for this series. "I wanted to marry the emotional content of color with the emotional potential of line in a very reductive way, which I think Schulz does so superbly," he says.

THE WORK

Like Schulz, Pruitt has a clean, minimalist approach to creating his drawings. "From Sharpie, to scanner, to Photoshop," he explains. While not as spare as Schulz's drawings—Pruitt fills in more areas and adds color—the works of both artists display a distinct unfussiness and a less-is-more approach.

As "one of the biggest fans of Peanuts," Pruitt's experience of poring over the Schulz archives was "a thrill," he says, but it was not necessarily what he relied on to create his interpretative works. Mostly, he relied on his own memory for the strips and characters "because that's what made it feel personal and real," he says.

What resonated for Pruitt was the friendships that abound in Peanuts. His curiosity was piqued by the friendship between Peppermint Patty and Marcie because he felt that they had the other's back. "Knowing from a relatively early age that I wanted to grow up to have a boyfriend, I found a nice example of a same-sex relationship with these two characters," says Pruitt. "It helped me feel less on the outside of things." He was also intrigued by what he saw as the more complicated friendship between Charlie Brown and Lucy. "Her attempts to control Charlie Brown, or should I say mess with him, seem to ring true to me," Pruitt says.

It makes sense that friendship would loom large in his creations for PGAC. Pruitt thought about all of the friends that exist in the strip juxtaposed with his self-described "own artistic alter ego of the panda." And that ego would choose Snoopy, albeit accompanied by a tiny bit of discomfort at the thought of coming between Snoopy and Woodstock.

FIGURE 6: Snoopy and the panda are climbing bamboo stalks. Snoopy is a bit nervous, "but the panda has hearts in his eyes because he's sharing his favorite pastime with his new friend," explains Pruitt.

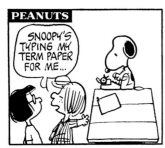
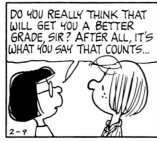
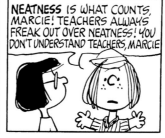
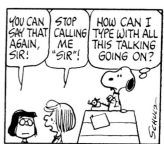

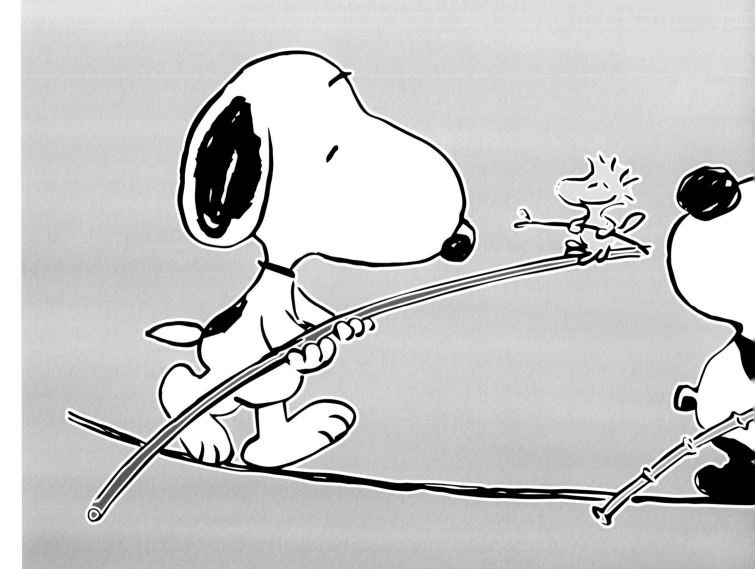

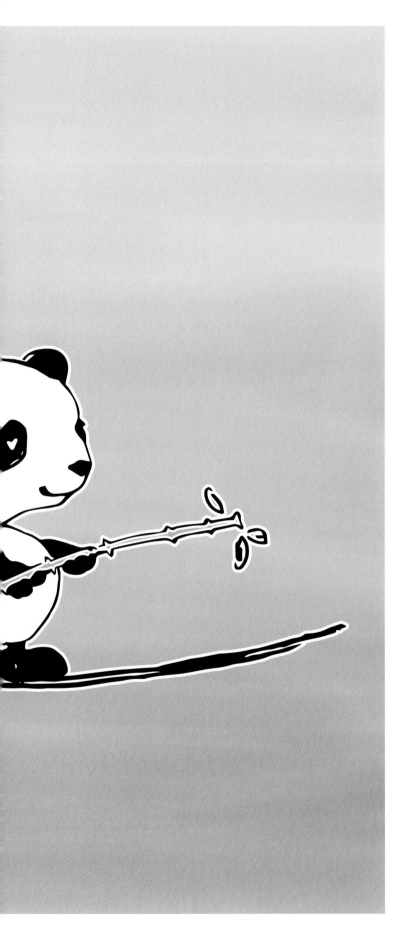

7.

The idea of friendship dominates all of Pruitt's renderings of Snoopy and the panda. Several interpretations offer a subtle narrative of the friendship that he imagines would exist between the two; others are more simple depictions of them interacting. In the pattern in Figure 6, he has placed the two against the panda's most essential food source: bamboo. The bamboo also becomes a jungle gym for Snoopy, which he is climbing with nervous trepidation. "But the panda has hearts in his eyes because he's sharing his favorite pastime with his new friend," explains Pruitt. He has set the pair against a gradient blue and green background reflecting a blue sky over a bamboo forest.

In Figure 7, Pruitt has reversed the dynamic from the bamboo pattern in Figure 6. "Here Snoopy feels quite at ease walking the tightrope with Woodstock as a counterbalance, whereas the panda feels a bit trepidatious." We can see Snoopy's confidence in the positioning of his feet, which are clearly bouncing along without difficulty, while the panda's feet are barely moving. Mindful of not allowing the panda to come between the friendship of Snoopy and Woodstock, Woodstock is being carried along by Snoopy, strategically placed between the panda and him.

FIGURE 7: Pruitt has reversed the dynamic from the bamboo-climbing pattern in Figure 6. "Here Snoopy feels quite at ease walking the tightrope with Woodstock as a counterbalance, whereas the panda feels a bit trepidatious."

8.

FIGURE 8: Pruitt's interpretation of Snoopy's familiar and classic pose, sleeping atop his doghouse.

FIGURE 9: Pruitt is portraying a scene that makes it clear that Snoopy's house is the panda's house, that he is welcome to make himself completely at home.

Riffing on the idea of *mi casa es su casa*, Pruitt takes the classic pose of Snoopy reclining atop his doghouse and reimagines it with the panda on top of a doghouse, rendered pagoda-style with bamboo supports (Figures 8 and 9). Woodstock is below, manning a doorbell depicted as a gong. Pruitt envisions eventually creating a composition that puts both images together in a checkerboard pattern.

Throughout Schulz's oeuvre, there are countless depictions of simple moments of friendship: Charlie Brown and Linus on a seesaw, Snoopy hanging out with Linus on top of his house, Woodstock bringing a flower to Snoopy, or the whole gang rocking out in a band. Pruitt has re-created these moments of friendship with Snoopy and the panda spinning on a strawberry-chocolate donut (Figure 5), playing on a seesaw (Figure 10), and cloning themselves to form a Beatles-like band (Figure 4).

--

FIGURE 10: Pruitt depicts simple acts of fun and friendship that run through Schulz's work.

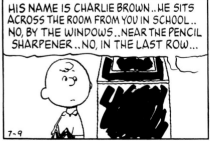
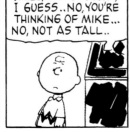
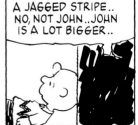
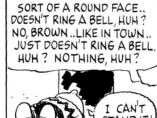

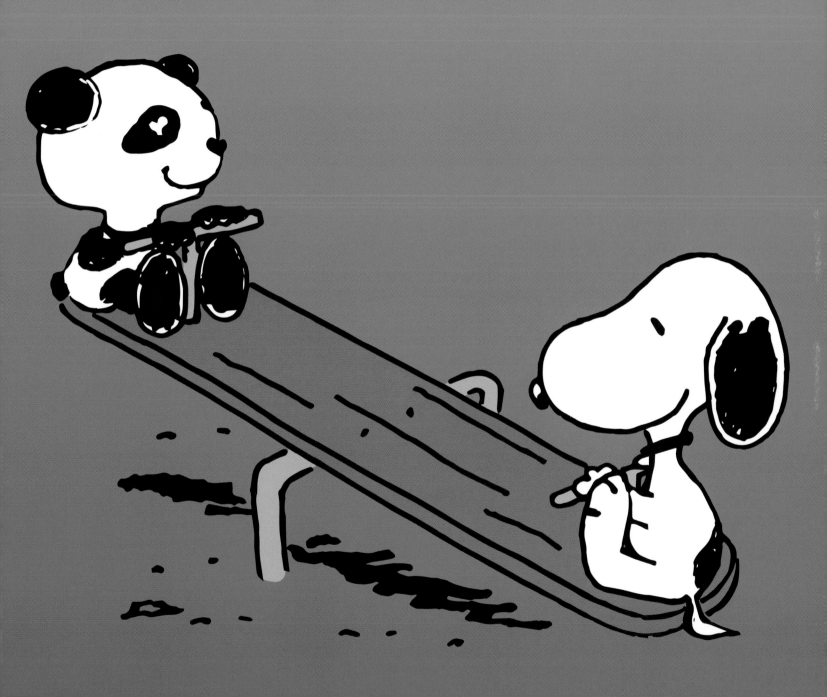

"PEANUTS IS JUST SO RELATABLE . . . AND NOT ONLY FOR CHILDREN'S LIFE, BUT FOR ADULT LIFE."

—K Schaf

KENNY SCHARF

KENNY SCHARF, along with Keith Haring and Jean-Michel Basquiat, formed the formidable triad at the center of the alternative art scene in New York's East Village in the 1980s. From Club 57, a basement bar on St. Mark's Place, they, along with a cadre of others that included film programmers Susan Hannaford and Tom Scully, and performance curator Ann Magnuson, were reacting with their work against the prevailing aesthetic, which insisted upon stark minimalism and overintellectualized conceptualism. Scharf and his group were anti-minimalist, anti-elitist, and specifically anti–School of Visual Arts, which foisted these austere tenets onto the downtown art scene. "No color, no representational figures, no fun at all. We were taught that art is supposed to be serious and something you suffer for. I was melting plastic dinosaurs over TV sets and laughing while I was doing it—the ultimate crime," said Scharf, in a *New York Times* feature by Brett Sokol about MoMA's October 2017–April 2018 show, *Club 57: Film, Performance, and Art in the East Village, 1978–1983*.

It is the laughter, the melting dinosaurs, and the time and place in which he grew up that makes this former East Village hipster and current ultra-cool Angeleno wholly compatible with the Midwestern everyman Charles Schulz. Born in 1958, toward the end of the baby boom, Scharf was obsessed "with the optimism of the time." He arrived in the age of Sputnik and at the dawn of television, which had the same seismic impact on the hearts, minds, and tastes of its generation as the Internet and social media has had on subsequent generations. "Maybe too much," says Scharf, of television's influence, echoing contemporary concerns about how much Internet is too much.

Much of the optimism was rooted in the suburban idyll—a concept borne out in the daily lives of the Peanuts gang, which made its television debut on December 9, 1965, with *A Charlie Brown Christmas*. Scharf's hometown, in Southern California's San Fernando Valley, was "a little bit Charlie Brown-y," he says, where metal milk delivery boxes adorned the porch of every

FIGURE 2: Against a conventional landscape of grass and sky, Scharf has rendered Charlie Brown with 3D qualities of iron sculpture, an approach he took for all of his PGAC artworks. Speedy, a familiar figure in Scharf's iconography, sits atop Charlie's head in a successful mashup of two artists' styles.

home, where traditional nuclear families lived, and kids walked to school. Scharf grew up surrounded by space-age dreams and architecture, endless streams of automobiles crossing rivers of freeways, and a torrent of commercials flooding living rooms and interrupting programming on a finite universe of just 13 channels. It was cartoons such as *The Flintstones, The Jetsons, Felix the Cat*, and, of course, Peanuts, with which Scharf was obsessed.

That same year, the Scharf family acquired their first color TV. "When no one was looking, I would sit this far in front of the screen," says Scharf, putting his hand up to his face. "In those days, if you looked, what you saw was basically a color field of bright colored dots on a black background. So this kind of psychedelic thing that I was just tripping out on as a 7-year-old made an impact," recalls Scharf, an impact that has had a profound effect on his work throughout the years. His work, be it paintings, murals, sculptures, or installations, explodes with fantastical shapes rendered in a volcanic eruption of primary and neon colors. While his daily dosage of cartoons came primarily from the TV screen, he was also an avid reader of two print comics: *Mad* magazine and the Peanuts books—all of them.

In addition to the influence of comics and TV during his formative years was the world outside, beyond the manicured lawns and backyard barbecues of the Valley.

--

FIGURE 3: The black, rounded three-dimensionality of Linus and Snoopy stand out against the primary colors of the flat stripes in the background. Scharf's Speedy figures are voyeurs, happily floating about, observing the scene.

3.

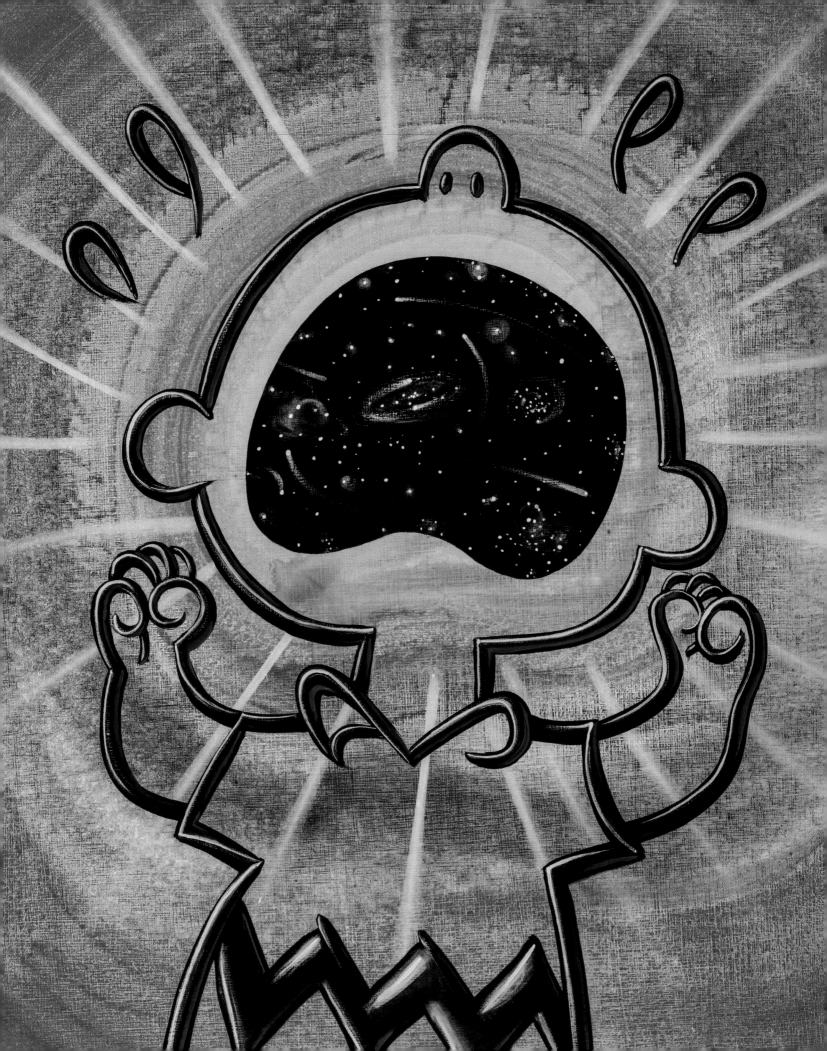

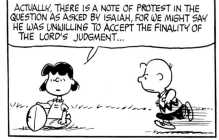
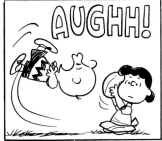

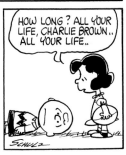

Scharf was intrigued by the art of the hippie culture—airbrushed van art and the omnipresent, neon-colored bubble lettering that adorned everything from Peter Max posters to 7 Up ads to graffiti-covered walls all over the world.

In 1978, Scharf moved to New York, because for an emerging artist, that was where "it was all going on." It was a time when, in Scharf's memory, "you could work a couple of nights a week to pay your bills and the rest of the time you were free. That's how cheap it was." He also remembers the subways and buildings of the city drenched in color, with everything from bubble-lettered tags to "pieces," graffiti vernacular for a complex, labor-intensive, and detailed painting. He immediately saw connections between the spray-painted art of New York and the cartoons and comics of his youth.

"I've been exploring the same themes since I was a little kid," Scharf admits, and those themes are rooted in cartoons. Scharf's obsession with cartoons is both exter-nal and internal. "They're actually something that is from inside me," he says. "Cartoons convey emotions in so many ways that young children can understand, something that explains their universal appeal to kids." In his own work cartoons function as "emotion emojis," as he calls them, although Scharf was employing the concept of portraying emotions through characters, color, shape, and expression long before emojis existed.

It's easy to apply the "emotion emoji" tag to Schulz's characters as well. What are Charlie Brown's "good grief" crinkly mouth visage (Figure 4), Snoopy's sunglasses-clad Joe Cool, or Linus and his blanket but emojis for disappointment, confidence, and insecurity?

--

FIGURE 4: Cartoons function as "emotion emojis," says Scharf, there being no better example than Chuck at his most frustrated. Here, Scharf has filled the inside of Chuck's mouth with the cosmos, perhaps a metaphor for the anguish that is a part of the universal human condition.

"You have these visuals that are so delightful . . . yet you also have darker, more complex themes."

FIGURE 5: Scharf plays upon the idea of the cosmos in a different way here. The Peanuts gang becomes the constellations of the night sky.

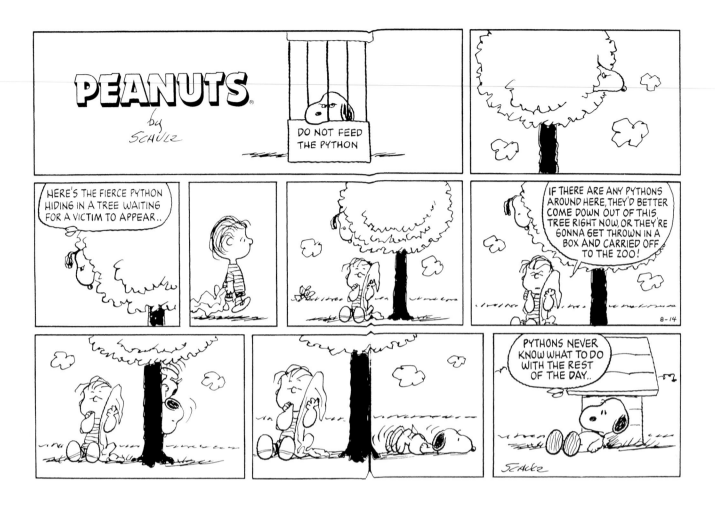

And Scharf, like Schulz, has always striven to get his art out in the world, to get it seen. "If you make it so that people can relate to it, or have some identification with it, you have a better chance," says Scharf. "I don't like esoteric things." At the same time, he firmly believes that art can elevate the masses, but not through "elitist-only" art because it is exclusionary. "I want to include everybody," a philosophy in harmony with Schulz. "Peanuts is just so relatable—the characters, the emotions, and the interpersonal relationships that it portrays are so classic—and not only for children's life, but for adult life," says Scharf.

When he started digging into the Schulz archives and poring over the images, he was immediately reminded of the joy he experienced as a kid devouring the entire Peanuts library. But looking at them as a mature artist,

he was taken with the universality of the Peanuts characters and the timelessness of the stories. Beyond the relatability of the messages was the art itself—the quality of the drawings. "I was loving the line quality. There's a thickness, and I really started looking at it and getting into it. It's not just this perfect line. It's this line that portrays all the variations of the emotions of the characters."

Scharf observed an ostensible effortlessness to Schulz's drawing, and was eager to capture this relaxed manner, but was faced with a challenge. "How do I depict these iconic characters of Peanuts and make them mine without taking anything away from them?" he asked. He was determined not to make them "less," because "they really are the stars," but at the same time he was equally determined to make them his own. "Otherwise, why am I doing it?"

FIGURE 6: "The iron sculptures," says Scharf, "celebrate the gestural quality and the great lines of Charles Schulz," as seen here, in which Scharf has captured the essence of the famously insecure Linus, right down to the drape of his blanket.

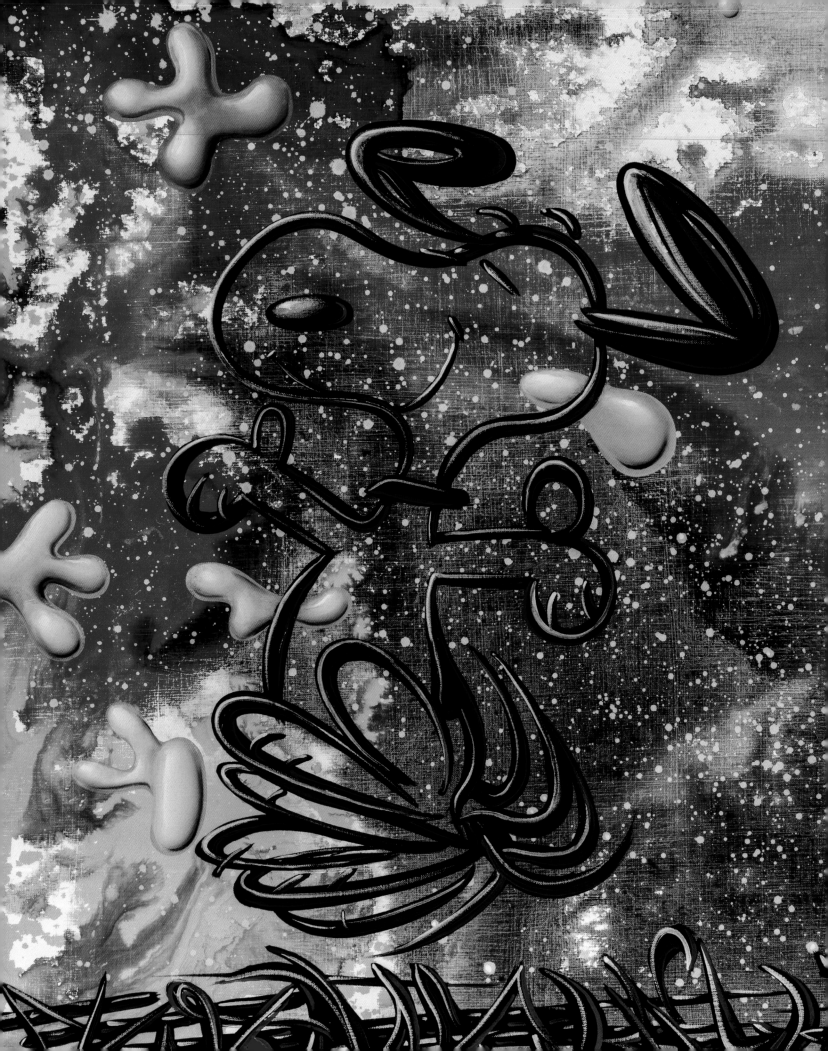

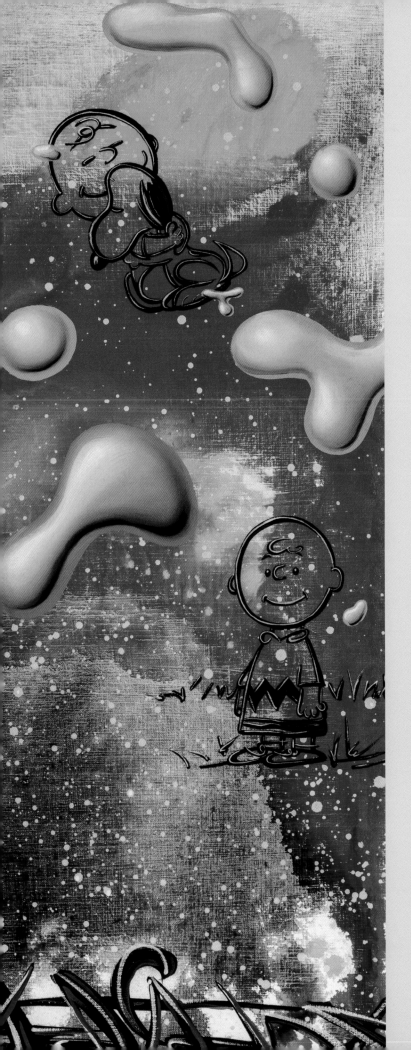

THE WORK

Scharf has depicted the drawings of Schulz as if they were wire or metal sculptures. Although this is an illusion he's created with paint, the effect is one of allowing the characters to appear as three-dimensional in a two-dimensional reality. Because they are neither static nor physically grounded, the figures appear as if floating against Scharf's colorful and effervescent backgrounds. The sculptural effect is achieved with thick, rounded lines that recall extra-thick strings of black licorice. Each segment is painted with shadow and light to accentuate their dimensionality. "The iron sculptures celebrate the gestural quality and the great line of Charles Schulz," says Scharf.

--

FIGURE 7: Snoopy is not weighed down by Scharf's "iron sculpture." Rather, it becomes a bouncy spring.

◀ 7.

Each of the paintings varies in the combination and proportion of Schulzian elements versus Scharfian. Some of the backgrounds are more like Schulz's (Figures 2 and 8), with a typical blue sky and green grass; others are more characteristic of Scharf's own work— bright colors joyously splashed erratically across the canvas (Figures 1, 6, and 9). In several, he has incorporated many of his own amorphous figures, shapes, and his trademark Speedy characters (Figures 1, 2, 3, and 8), which are ball-faced creatures with tails, varying in size and shape. In these works, they are "just like around in the atmosphere, watching what's going on with the Peanuts characters," notes Scharf.

As much as the characters have become emblems for various states of the human condition, ranging from disappointment, anger, and confidence to insecurity, unrequited love, and joy, so have particular tableaus, notably when Lucy pulls the football away just as Charlie Brown is about to kick it. That scene, says, Scharf, "is such a metaphor for so much in the whole world all the time," from the littlest scale in a child's life to global politics.

--

FIGURE 8: The countless times when Lucy pulls the football out from under Charlie Brown "is such a metaphor for so much in the whole world all the time," from the littlest scale in a child's life to global politics, says Scharf.

FOR THE LOVE OF PEANUTS

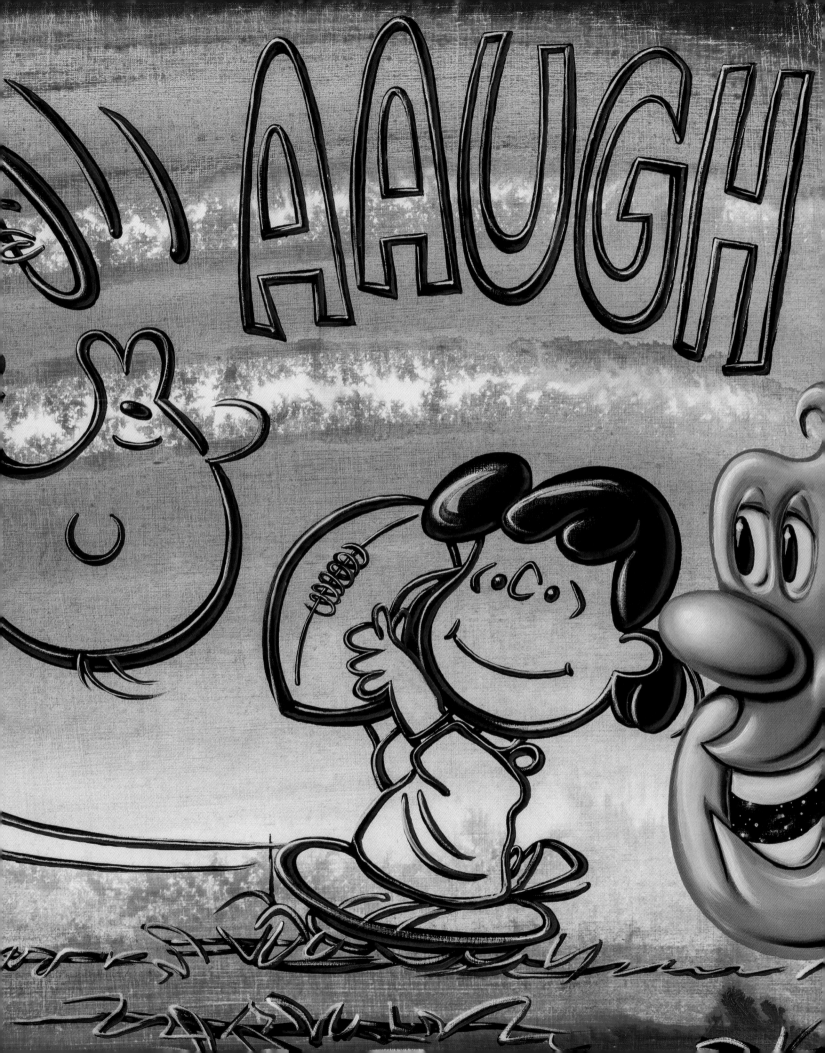

Like Peanuts, Scharf's work is more than the sum of its cheery, happy shapes, figures, and colors. The playfulness of his work often belies darker messages and themes. "I don't like to bash people on the head with issues, but they are definitely part of my work. I don't pretend that everything is okay," he says. Peanuts does things in a similar but different way. "You have these visuals that are so delightful, with touching stories of the human heart, yet you also have darker, more complex themes that are apparent, but are explained in a way that kids can understand."

--

FIGURE 9: Playing with proportion, Sally looms large while Charlie Brown is elevated on one of Scharf's fantastical landscapes: swaths of color with graffiti-like swirls and stars.